IMAGES
of America
SIGNAL HILL

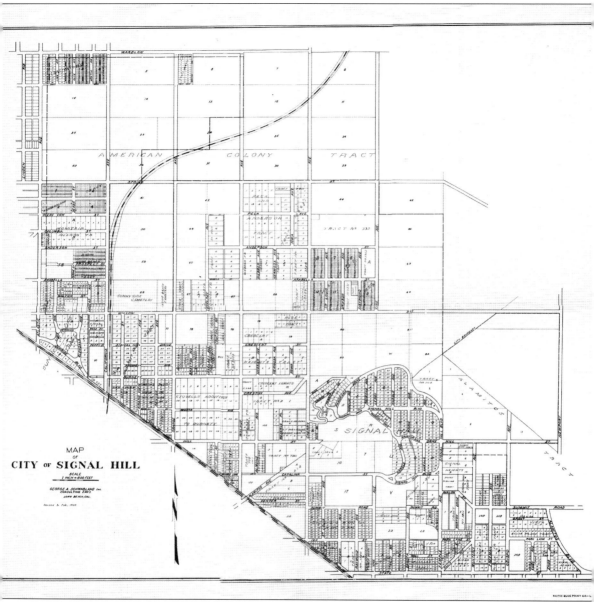

This is a partial view of the original Signal Hill charter map from 1925.

ON THE COVER: Investors take a look at General Petroleum's Black and Drake Well No. 1, just after it struck oil in 1922. The tremendous pressure from the recently discovered oil field blew the top of the derrick.

Ken Davis and the Signal Hill Historical Society

Copyright © 2006 by Ken Davis and the Signal Hill Historical Society
ISBN 0-7385-3073-5

Published by Arcadia Publishing
Charleston SC, Chicago IL, Portsmouth NH, San Francisco CA

Printed in the United States of America

Library of Congress Catalog Card Number: 2005932496

For all general information contact Arcadia Publishing at:
Telephone 843-853-2070
Fax 843-853-0044
E-mail sales@arcadiapublishing.com
For customer service and orders:
Toll-Free 1-888-313-2665

Visit us on the Internet at www.arcadiapublishing.com

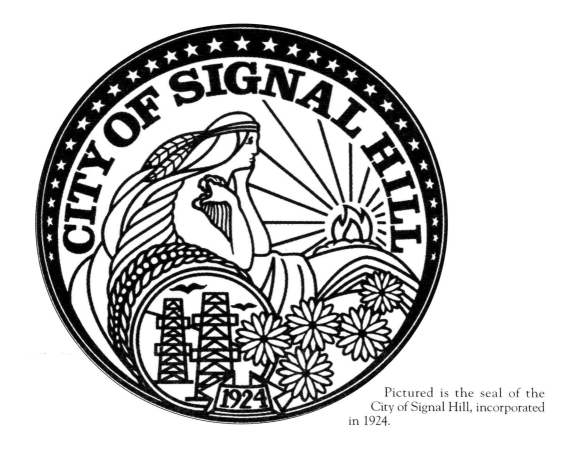

Pictured is the seal of the City of Signal Hill, incorporated in 1924.

Contents

Acknowledgments 6

Introduction 7

1. Farms and Ranches 9

2. Early Oil Years 25

3. People and Events 53

4. Fires and Disasters 79

5. Homes and Street Views 101

Acknowledgments

As archivist and past president of the Signal Hill Historical Society, I have been combing through photographs, records, and historical articles on the city for the past four years. This book is a product of those efforts and could only have been completed with the support of the City of Signal Hill staff and the members of the historical society. The images and caption information for this book were drawn from the combined collections of the City of Signal Hill and the Signal Hill Historical Society, with the few exceptions noted in the captions.

 I am deeply indebted to Mayor Michael Noll, who inspired me to get involved in this community when I first moved into town, and to Luis Morente, for his encouragement and support, with which this book could never have been completed. And lastly, I need to thank my parents, who instilled in me a deep respect for our history.

INTRODUCTION

Signal Hill rises only 364 feet above relatively flat lands of the southern portion of the Los Angeles Basin. Native Americans, and later Spanish explorers, used this hill as a lookout and vantage point to survey the surrounding land. In 1887, a surveyor placed a triangulation marker atop the Hill as part of the Los Angeles baseline map, and Signal Hill received its first official recognition. The first owner of record of the Hill was Don Manuel Nieto, who acquired this land within an immense 300,000-acre grant in 1784 from King Carlos III of Spain. Nieto's holdings spread between the Los Angeles and Santa Ana Rivers and from the San Gabriel Mountains on the north to the Pacific Ocean on the south. Grazing large herds of cattle and horses, Nieto was one of the wealthiest men in early California. After his death, the land was divided into many large ranchos. Nieto's son Don Juan Jose received Rancho Los Alamitos, and daughter Dona Miguela inherited Rancho Los Cerritos. The borders of these ranchos ran along what is now Alamitos Avenue and across the top of Signal Hill.

In 1866, Llewellyn Bixby bought Rancho Los Cerritos for about 80¢ an acre. Other Bixby family members later bought Rancho Los Alamitos for $125,000, and the areas were combined and converted into sheep ranches. In 1880, William Wilmore purchased an option on 4,000 acres with the hopes of creating a fashionable residential community. His efforts to build Wilmore City failed, but others carried out his dream and the City of Long Beach was born.

At the end of the 19th century, only a few homes, farms, and ranches were sprinkled across the land that is now known as Signal Hill—the stage where this book's images begin. Lewis Denni founded a cheese factory and, with some of those earnings, purchased the first hilltop home from G. W. Hughes, president of the Signal Hill Improvement Company. Hughes subdivided the prime hilltop area and brought in water and electricity, and saw the slopes of Signal Hill as an ideal location for stately homes. The 360-degree views of the southland, with its mountains and coastline along with the gentle ocean breezes, made for an ideal residential site. Only one thing got in the way of Signal Hill's envisioned destiny of hilltop estates—oil.

After World War I, foreign companies were allowed within the United States to explore for oil. Although geological data showed the promise of petroleum in the Signal Hill area, most oil companies shied away from drilling in populated areas. But Royal Dutch Shell purchased 240 acres on the southeast side of the Hill and started to drill. O. T. Yowell lived up to his nickname, "Happy," when he drilled the Hill's first wildcat gusher on June 23, 1921. He had just tapped into one of the state's largest oil fields, starting a "black gold rush" to Signal Hill. Many more wells were drilled and the derricks started going up everywhere. Roughnecks, gamblers, prostitutes, and investors all came to be a part of this new boom town. Lots were sold off in small parcels, and oil wells were built so close together that you could step from one well to the next without touching the ground. Swindlers sold worthless shares in wells to unwitting East Coast investors, as word of this newfound bonanza spread across the country.

The City of Long Beach hoped to annex this unincorporated area of Los Angeles County for a chance to capture a share of the action in oil taxes. The oil companies quickly organized

the boomtown's 2,000 residents and formed their own city to keep control. So in 1924, they incorporated and elected the first female mayor in the state of California, Mrs. Jessie Nelson. That is how two square miles completely surrounded by the city of Long Beach became the independent city of Signal Hill.

During the boom years, a gusher would come in nearly every week. One by one, the homes near the wells were destroyed by oil showers or pelted by rocks projected out of the gushers. If that was not enough, fire and explosions shook the area. Yet in many parts of the city, everyday life went on amid all the commotion. Gambling and dance halls brought a notorious image to this town, along with some colorful characters operating on the edge of legality. Yet during World War II, Signal Hill did its part and was a significant supplier of fuel to the nation's war efforts.

By the 1970s, oil production was in decline, and in the 1980s the city looked to redevelop some of the land left by the oil companies around Cherry Avenue and Spring Street into an auto mall. That success fueled the efforts to bring Price Club and Home Depot to town, and a new sales-tax base was formed. Recognizing the need to rebuild the residential and commercial areas, the city built the required infrastructures. The owners of the consolidated oil interests in town focused their energies on real estate development of the hilltop. After cleaning up the land from years of oil operations, new estate homes began their return to the hilltop. Consolidated drilling sites were hidden between the homes and in parking lots. Although wells are still in operation today, they are much harder to find. Now the homes have pushed out the oil wells, and Signal Hill is finally fulfilling its destiny as the prime location to live and enjoy the coastal breezes and dramatic 360-degree views.

One
FARMS AND RANCHES

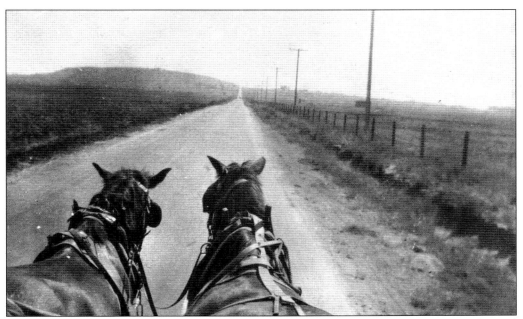

This photograph puts the viewer in the driver's seat of a horse-drawn wagon traveling to Signal Hill. Not a tree was in sight in the late 1880s. Who could have imagined that what was in store for the small dome hill dividing the California ranchos?

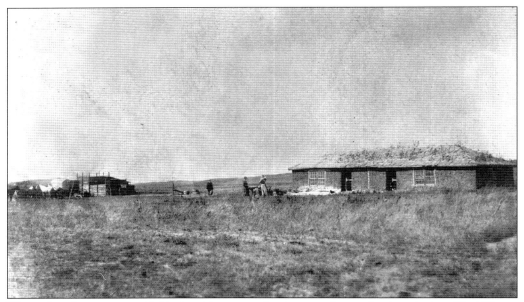

The only information available for this very early photograph was the inscription, "Sod House of Peter Waters." Reminiscent of the homes on the prairies of the Central Plains, it was a bit out of place here on the West Coast. It must have been a great relief to these early settlers to have found the agreeable climate of Southern California.

Ray Mace took this photograph from the top of the barn at his home at Twenty-seventh Street and Walnut Avenue, looking southeast towards the Hill. The Cullen home is in the foreground, and the distant clump of trees in the background marks the Hess home.

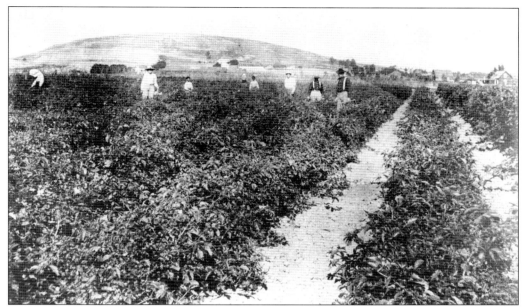

This is a 1906 view of the dewberry farm owned by T. L. Vore. Ranches gave way to farms in this area around the turn of the century, and Mr. Vore was one of the larger farm owners. Dewberries are described in today's terms as blackberries. Note the barren slopes of the western side of the Hill in the background. This photograph was taken from behind the Vore family home looking east from what is now Twenty-third Street and Orange Avenue.

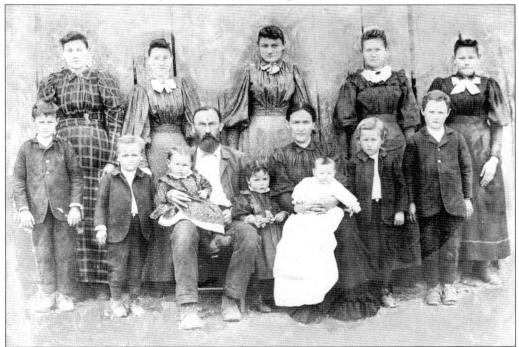

Although it is not known who these local settlers were, this image lets the mind run wild with speculation on what their stories and circumstances might have been.

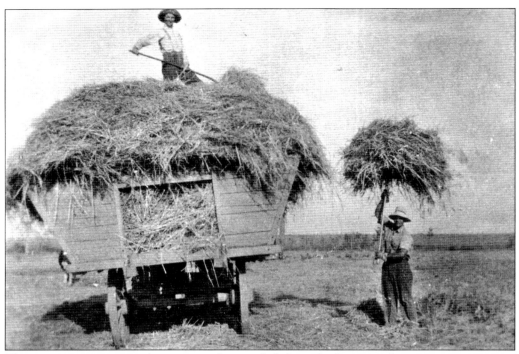
These young men seem to be enjoying their work forking the hay onto the wagon.

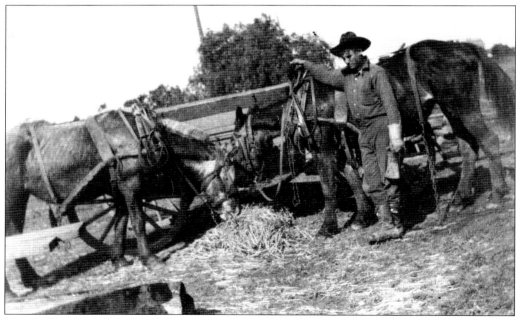
Marvin Dreggar takes a break from operating this bottom dump wagon near State Street (Pacific Coast Highway) and St. Louis Avenue to feed his team of horses.

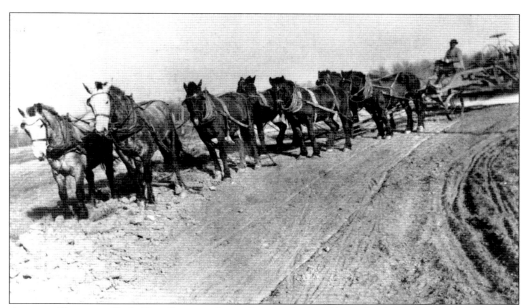

A team of horses pulled a Roadking grader with an eight-foot blade that helped to level the bumps out of Cherry Avenue. Cherry later became the first bonded road in Los Angeles Country.

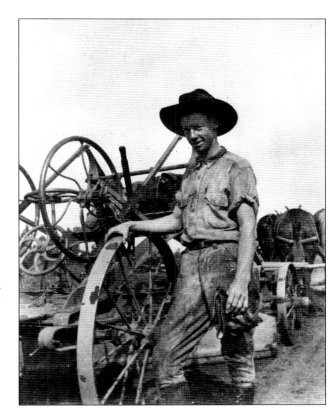

Ray Mace was 19 years old in 1919 when he photographed the Roadking grader, shown above, and when his sidekick Marvin Dreggar (seen at top of page 12) took this photograph of Ray. He is standing by the pull grader he had been operating on the northwest slope of Signal Hill near Cherry Avenue and Willow Street. How fortunate that this young man's interest in photography helped capture the everyday life in early Signal Hill.

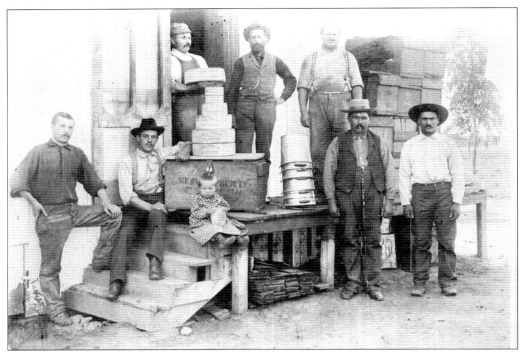
Lewis Denni's and Reeves' Alamitos Cheese Factory is depicted here around 1892. This business venture provided the resources, prior to the oil boom, to allow Denni to purchase his home on top of Signal Hill.

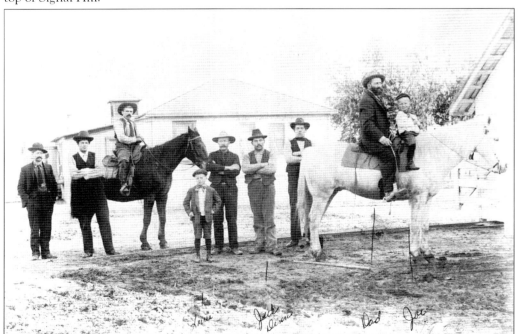
Young Joe Denni sits in front of his father on the horse, with other sons Lee (third from left) and Jack (fourth from right) standing in this photograph.

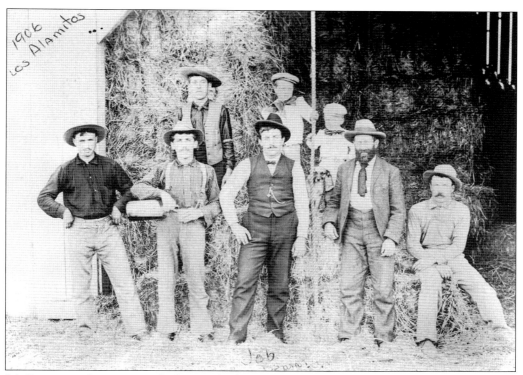

Jeb Denni, in the center with the watch chain, is left of the bearded Louis Denny in front of the barn.

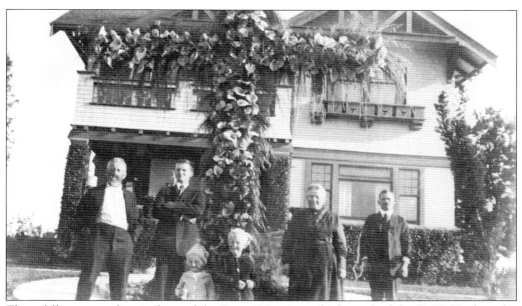

These folks are standing in front of the Denni Mansion, which was built by G. W. Hughes, the original developer of the hilltop area along what is now Skyline Drive (see pages 22 and 23).

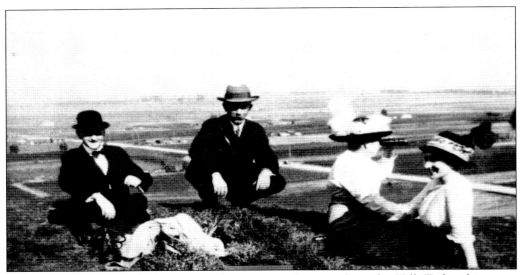

This early photograph shows two couples enjoying the view from the Hill. Today this scene is relived many times over from the city's Hilltop Park, with fashions changing more than the experience itself.

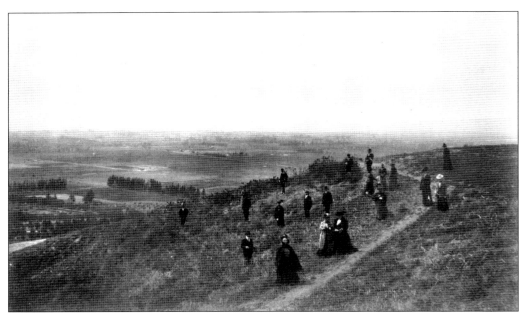

This group settled off the path to take a photograph documenting this day on the Hill in the late 1800s. Judging from the well-worn trail, this was a common area to walk.

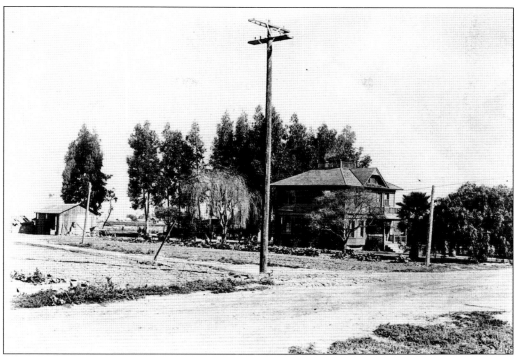

This 1917 photograph shows the C. F. Hess home. Mr. Hess traded this farm for a ranch in Fairmead only six years before the oil boom hit, missing out on the opportunity of a lifetime.

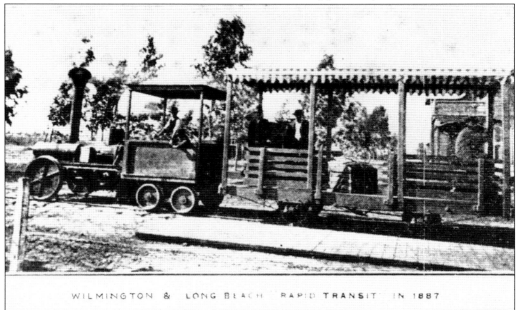

Judge Whitney's "GOP Railroad" was so nicknamed for the phrase "Get out and push." It was upgraded from a horse-drawn operation to this transportation system with a steam-driven engine. It carried passengers to land sales on the Hill from the larger railroad-station line. Long Beach was then called Wilmore City and tracts of land were being offered across the whole area.

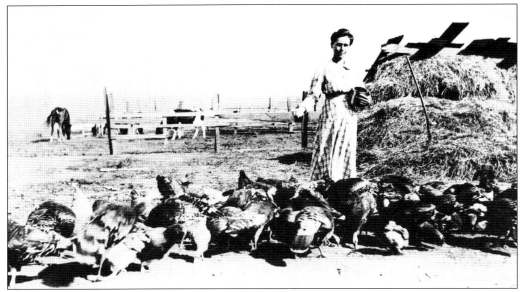
Feeding the turkeys on the Mace Farm was one of the countless chores in everyday life on a farm.

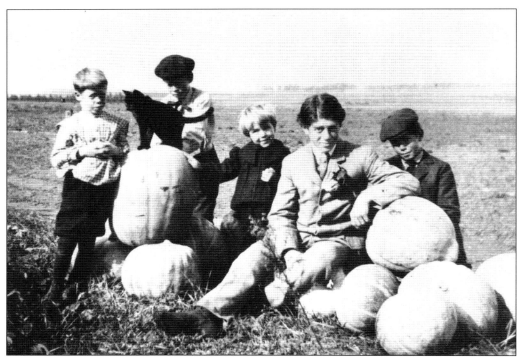
A playful day is depicted on the Mace Farm with, from left to right, Ray, George, Hugh, Herbert, Ben Mace, and Sprangles the cat sitting atop a collection of cow pumpkins. Mace family sources place the year as 1908. The location is Walnut Avenue and Twenty-seventh Street.

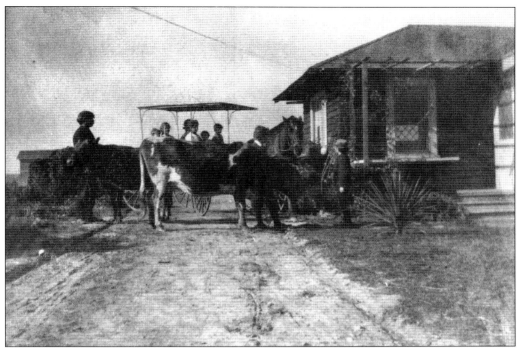

Cows, horses, and a surrey all got into this Mace family photograph in front of the house. Farming was a tough life in those days, but this photograph indicates that it can also be a good life.

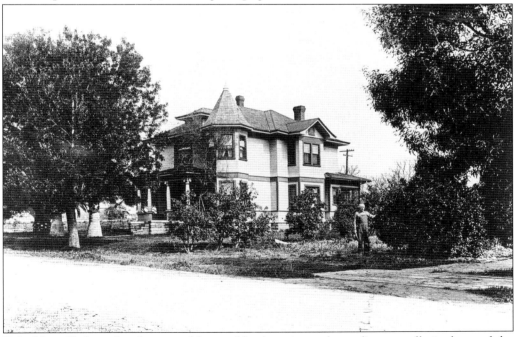

T. L. Vore (father of early mayor Vernon Vore) is pictured standing proudly in front of the old Vore home that was built in 1905 on the southeast corner of Twenty-third Street and Orange Avenue.

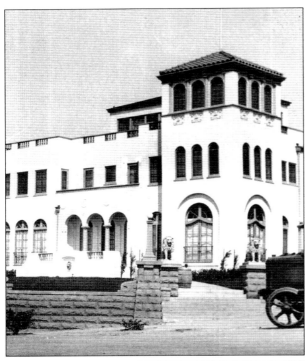

The Pala Mansion, pink in color, was still considered new when oil was discovered on the Hill. The architectural design was Spanish, with an abundance of windows to allow the family to enjoy the 360-degree views their hilltop home afforded.

This gravel operation provided building materials for the rapidly growing southern Los Angeles County region. Signal Hill was giving up more than just oil.

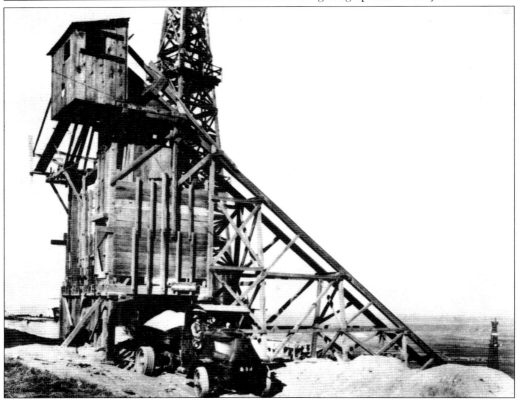

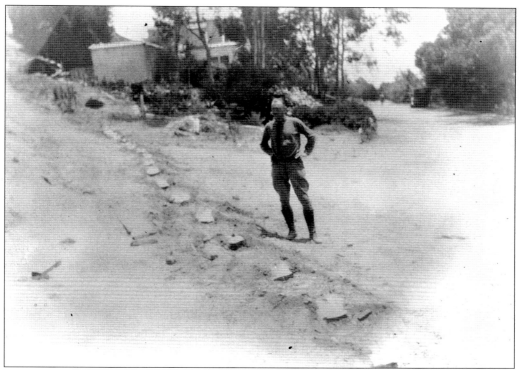

Mr. Johnson, from the city water department, helps give some perspective at the intersection of Twenty-first Street and Stanley Avenue as it juts up to the left toward the hilltop.

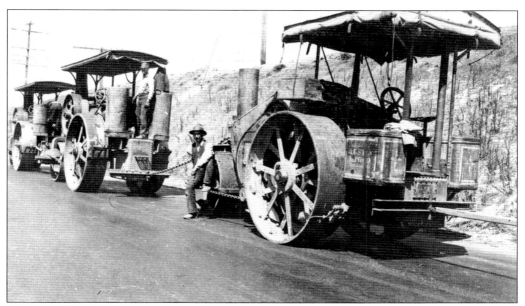

This 1919 photograph by Ray Mace depicts Sam Gormelee, standing, and Bill Morris. Ray was a swamper on one of these rollers. These are Los Angeles County Road Department rollers, which had just finished up work in Signal Hill and were about to return to Compton for repairs.

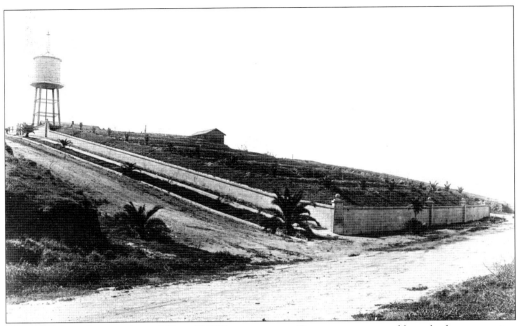

G. W. Hughes, the president of Signal Hill Improvement Company, promoted lot sales by comparing the area to an "American Italy" with its Mediterranean climate. Hilltop lots were 60 feet by 130 feet and came with 35 shares of the Signal Hill Water Company, along with access to their own electric power plant. "Reliable estimates show that every lot and home in the tract would not exceed $1 for both water and electricity." This 1900s image looks southwest from Panorama Drive up Junipero Avenue.

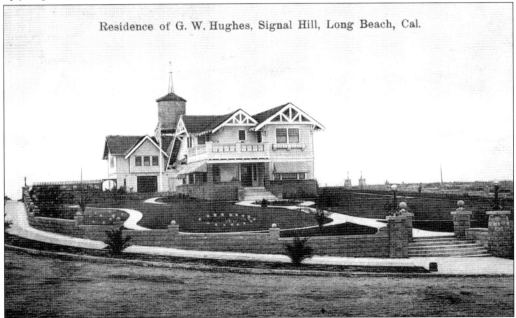

The opposite side of the above lot faces the street that is now Skyline Drive. Note the water tank in the background behind the house.

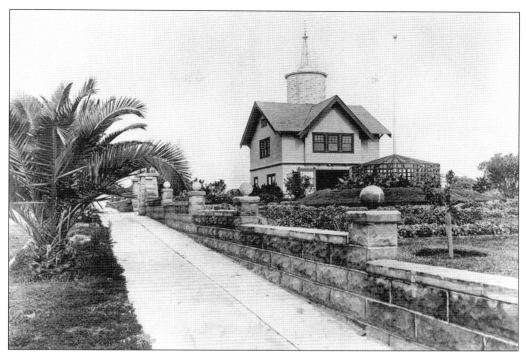

This photograph of the Denni Carriage House around 1914 shows the water tank and garden behind the main house that supplied water to these prime lots on the hilltop. Later this carriage house was moved to make room for the oil and was used as the Sky Room (see page 72).

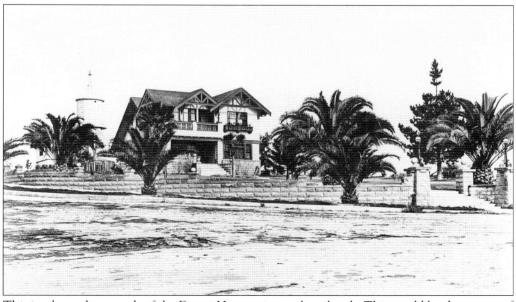

This is a later photograph of the Denni Home prior to the oil rush. This would be the corner of Raymond and Skyline Drive (Twenty-third Street).

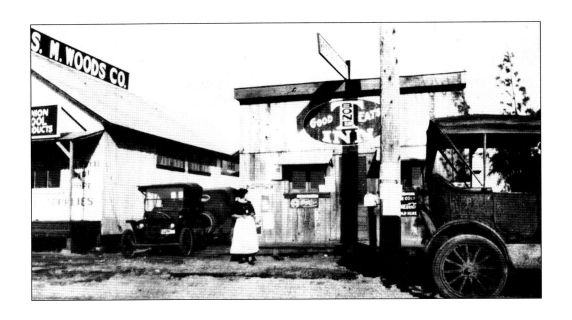

On the west side of the 2900 block of Cherry Avenue sat T-Bone Good Eats Inn and Chas Woods Company tools and supplies. This area of town is now dominated by new car dealerships, supplying the second boom to Signal Hill in the form of sales-tax revenues.

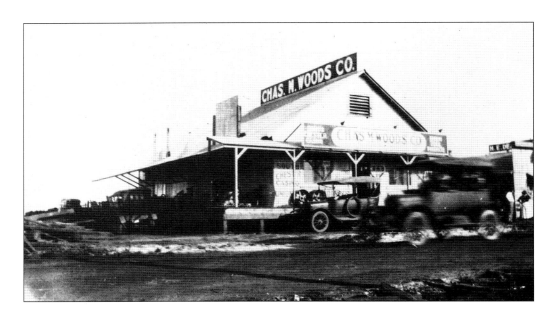

Two

Early Oil Years

In 1916, the first oil well was drilled on the Hill. Union Oil sank a 3,449-foot-deep hole at Wardlow Road and Long Beach Boulevard, coming up just short of the oil pool below and thus abandoned the shaft. Following the close of World War I, the federal government allowed foreign investors to search for oil in the United States. Royal Dutch Shell (British and Dutch owned) took that offer and gambled $60,000 on a lease of 240 acres on the southeast flank of the Hill. O. T. "Happy" Yowell was in charge of drilling and was considered one of the best in the business. Shell was ridiculed by rival oilmen, who boasted they would drink every drop of oil found in Signal Hill. After three months of drilling, on June 24, 1921, just before dawn, Alamitos No. 1 began to gush. This was the wildcat well that changed Signal Hill forever. At right is Discovery Well, Alamitos No. 1, which is still an active well and can be seen at the corner of Hill and Temple.

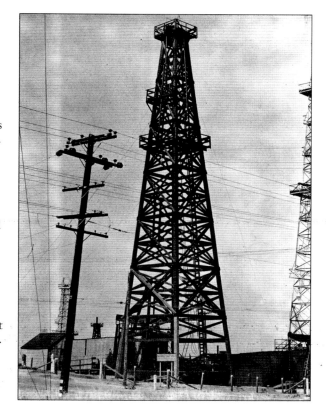

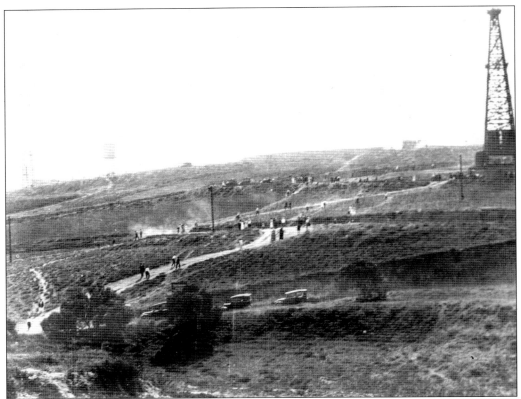

This early photograph, most likely taken late in 1921, looks at the northwest side of the Hill showing the barren slopes with only a few oil derricks in sight. Note the water tower (at left) near where is now the Panorama walking trail. The tower was built only a few years prior to help sell lots for view homes, but those plans gave way to oil.

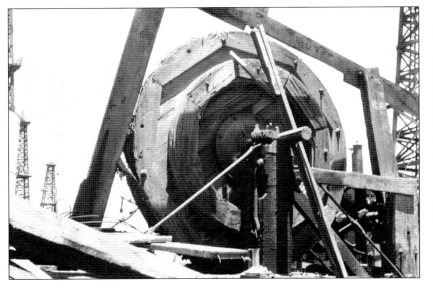

Here is a wooden bull wheel left in the oil fields after being replaced by a steel version. This one was used on the Turner No. 8 well. Note the photograph at right shows a similar wheel in use in the makeshift room surrounding the wellhead.

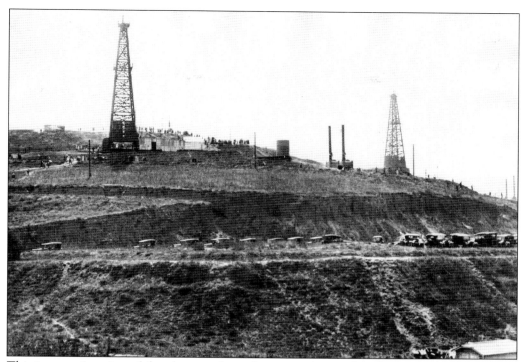

This is a continuation of the photograph on the opposite page that shows a makeshift parking lot and teams of people climbing up the slope to see the latest happenings. This is most likely Cherry Avenue, south of Burnett Street, where the cars often parked.

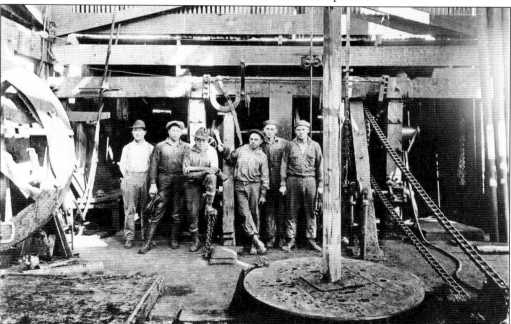

In 1923, this Signal Hill drilling crew poses for the camera. Pictured, from left to right, are Fred Spreen, Otto Kinney, John Augsberger, Roy Blodgett, and unidentified.

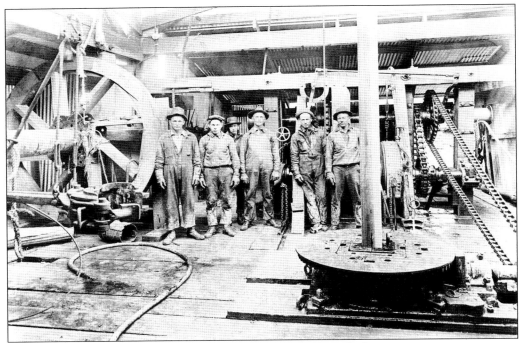

Members of a 1922 Signal Hill drilling crew pose by a drilling platform.

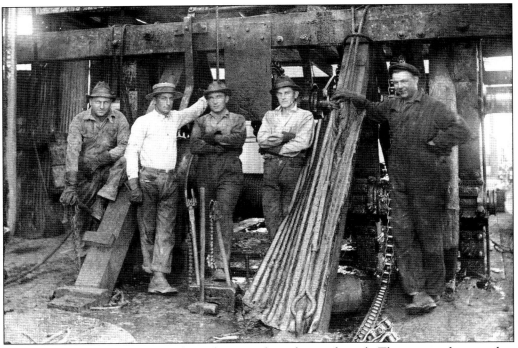

A drilling crew from the 1920s takes a short rest from the tough work. The man in the straw hat seems more like the owner than an actual worker with such a clean white shirt. (Photograph courtesy of Neena Strichart.)

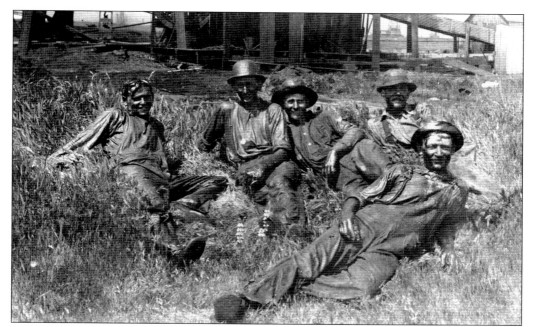

Drilling for oil is not an easy job. These guys seem very happy to be bathed in liquid gold after capping off a gusher. Maybe they got a bonus or are just proud of being on a successful team with a producing well.

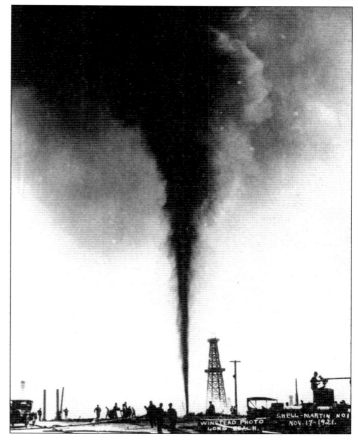

Shell Martin No. 1, pictured here on November 17, 1921, was one of the early wells on Signal Hill. A closer look shows the crews trying to get this rig under control.

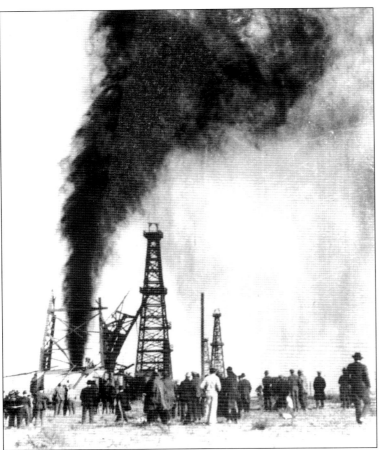

General Petroleum's well Black and Drake No. 1 blew in January 21, 1922, and was one of the longest gas-and-oil gushers in the history of the Hill.

Black and Drake's blast bathed the area around Willow and Walnut for blocks. The shower of oil and muck thickly covered everything in its path.

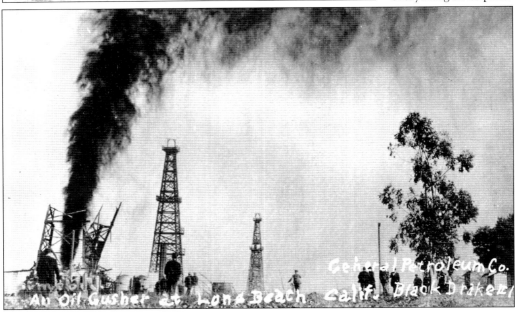

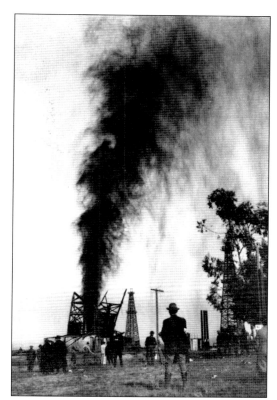

The sheer power of the oil gushing from the earth blew off the top half of the derrick. This is the same gusher that is featured on the cover of the book.

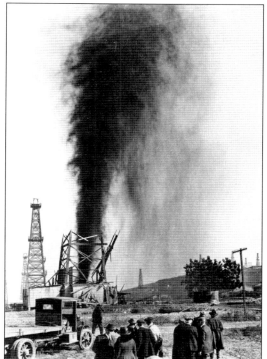

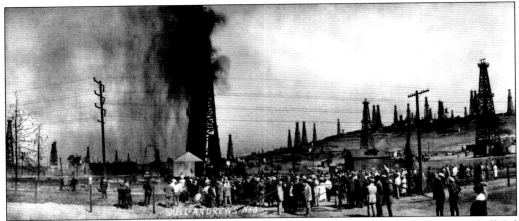

These two photographs show the crowds gathering to watch the crew of the Royal Dutch Shell Oil Company fight to cap the gusher at this new well, named Andrews No. 3. It could take days to cap a well, and as word spread across the area everyone would stop by and see what was going on.

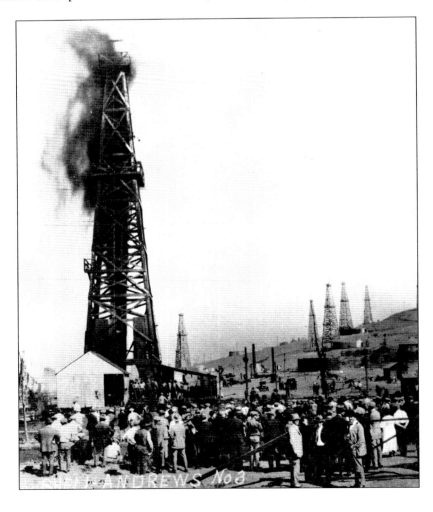

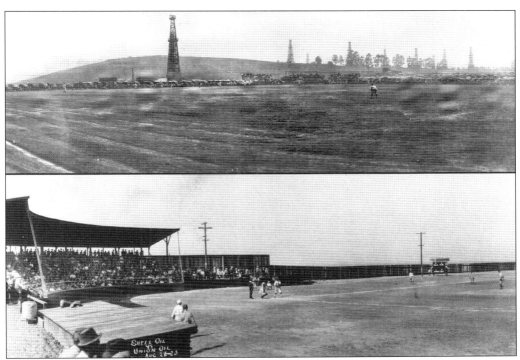

The oil companies organized professional-quality baseball teams to give the workers something to do in their spare time. The game pictured above is Shell Oil versus Union Oil, played on August 26, 1923, at Shell Field. The oil companies encouraged a competitive environment, though knowledge of the winner of this game is lost to history. A group shot (below) shows the camaraderie of the drilling crew who teamed up to get the well to produce.

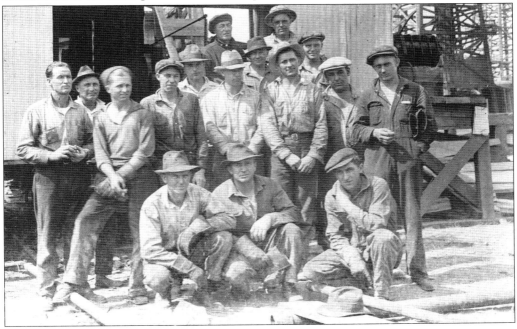

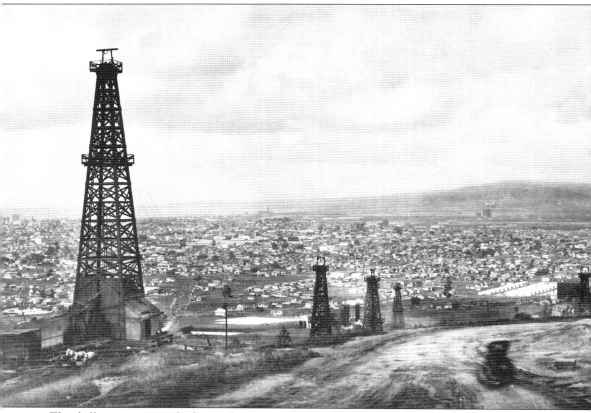

This hilltop panorama looks southwest to Palos Verde on the horizon and San Pedro and Los Angeles harbor to the left. A portion of the buildings of Long Beach are visible at the left edge. Note the horse-drawn team working on the left derrick, and a car rushing along the south face

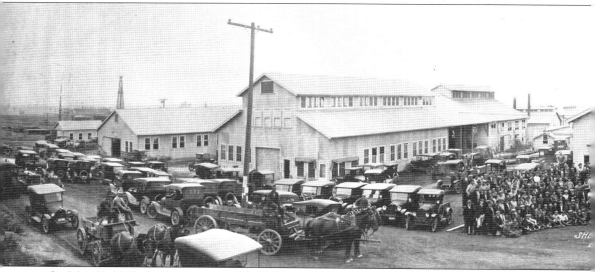

On May 21, 1925, this large group of Shell Oil employees poses in front of the company buildings, showing how many workers they had at that time. Two horse-drawn teams work alongside the

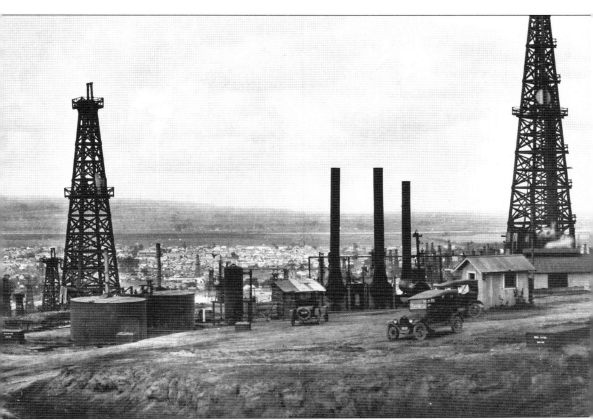

of the hilltop to one of the working wells. Also note the rows of tents along Cherry Avenue and Twenty-first Street just above the car, hastily built to house the huge population of new workers coming to make their fortune.

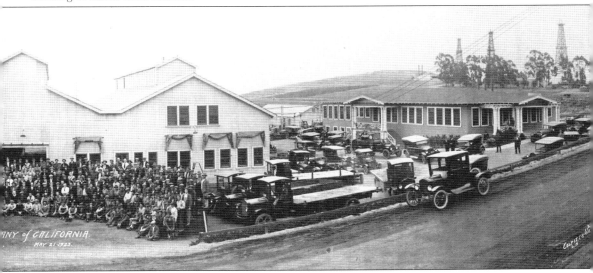

row of automobiles and trucks fed by the oil extracted from the Hill.

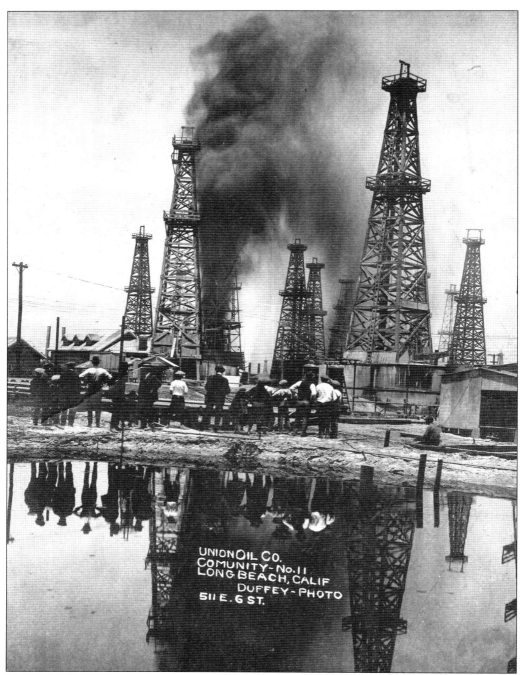

Union Oil Community Company's Well No. 11 drenched the homes in this Crescent Heights neighborhood. The area west of Cherry Avenue between Burnett and Twenty-fifth Streets was the site of many upscale homes. They were pelted with rocks and oil blasted from the ground and very few survived. The City of Signal Hill has recently designated this area as a historical district to preserve the existing homes and encourage others to relocate vintage homes or build new ones with the same architecture of that time.

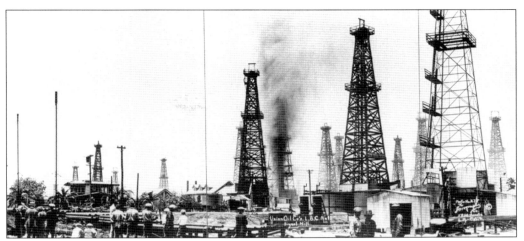

Here is another view of the Crescent Heights gusher spreading oil onto the surrounding homes. With so much oil gushing onto the land, it had to go somewhere. Sand dikes were built to temporary hold the flow, but they could only catch so much. That leads to the photograph below.

Hamilton Bowl, along Walnut north of Pacific Coast Highway, was built to catch the runoff from the Hill. If a gusher blew oil onto the streets, it would run through flood-control pipes to be captured in Hamilton Bowl. It is still used today to collect rain runoff and filter out trash before being diverted to the Pacific Ocean. Most of the area residents know it as Chittick Field Recreation Park.

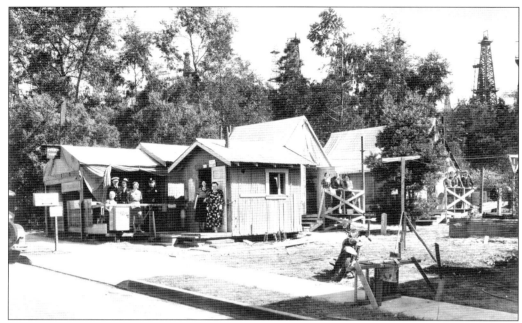

In order to avoid paying oil taxes if annexed into Long Beach, Signal Hill voted to incorporate as its own city. Here is the first city hall with fire, police, water, and planning departments all sharing the temporary offices. Jesse Nelson was elected mayor in 1924 and became the first woman to hold that office in the state of California.

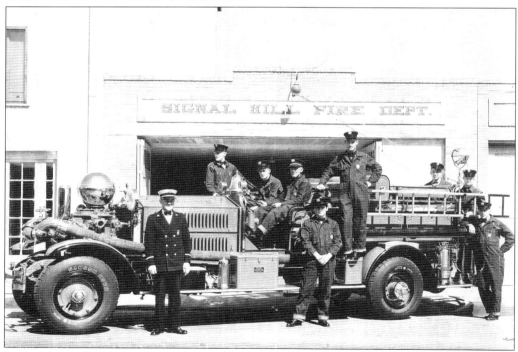

Later the first fire station was set up on Cherry Avenue, just north of Nineteenth Street. Here Capt. Adolph Feil is pictured in front of his new station (as well as in the top image, at left).

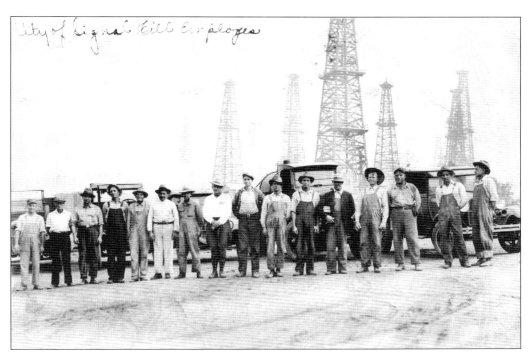

It took a lot of work to put together this new city in the midst of an oil boom, but these guys seem eager to get the job done. Both of these photographs appear to be of the same 16 city employees. The date on the top image shows 1921, but the City of Signal Hill did not incorporate until 1924. Someone may have mistaken the date when oil was discovered and mislabeled the photograph.

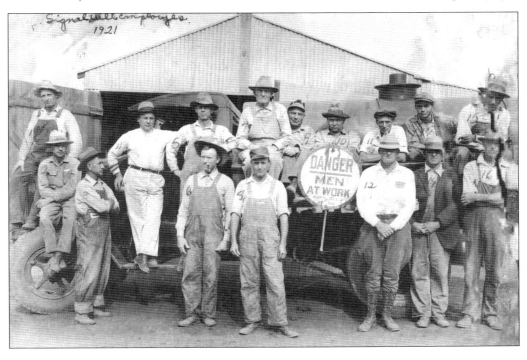

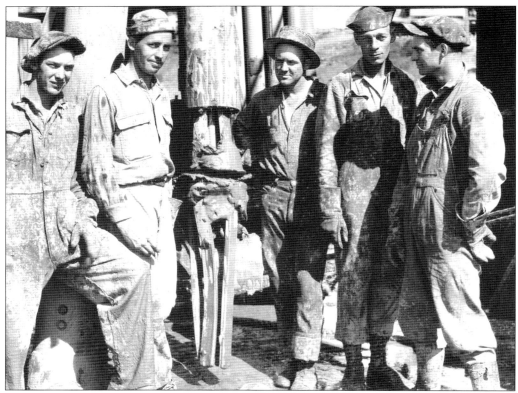
Unfortunately, the names of these workers have not been identified yet, but their efforts in building the oil industry have not been forgotten. Their faces seem to tell their own story.

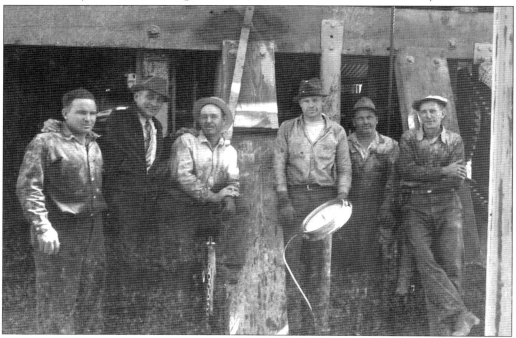

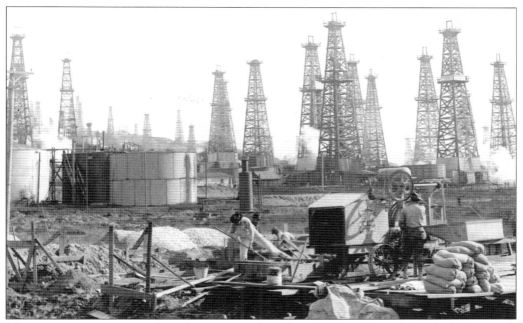

Men put cement in casing along the western side of Signal Hill in the early 1920s. (Photograph courtesy of Mark Fowle.)

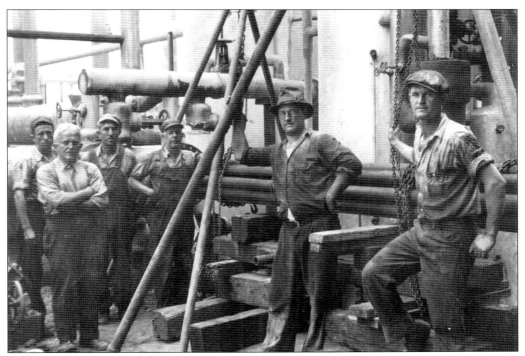

Here is another group of workers eager to take a break to have their photograph taken during the construction of Signal Oil and Gas's Plant No. 2.

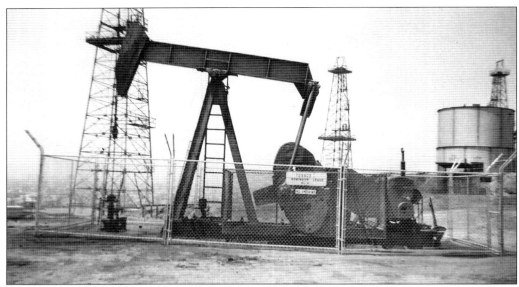

This 1960s vintage pumper, with steel derricks in the background, is a more familiar image for most of the readers. It is, however, not as romantic as the old wooden derrick on the next page.

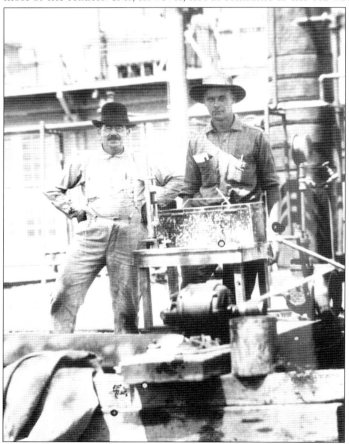

A lot of science is involved in getting oil out of the ground. These gentlemen are running some tests to make sure everything is in order.

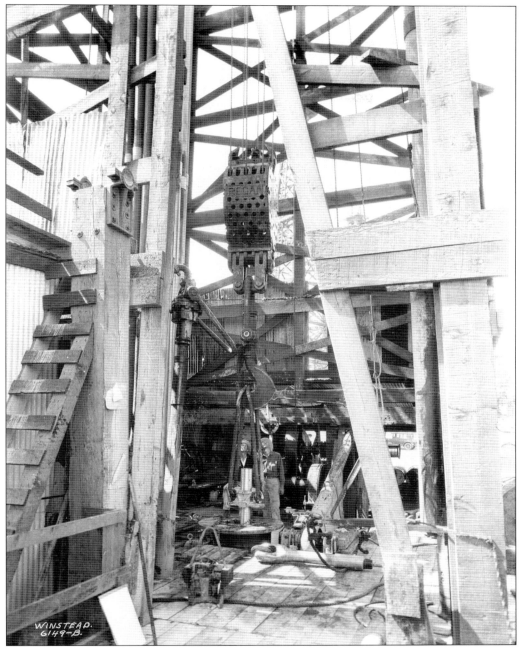

The sheer size of this derrick and timbers is very impressive, as is the 8-by-10-inch photographic negative in the Signal Hill Historical Society collection from which this image was taken.

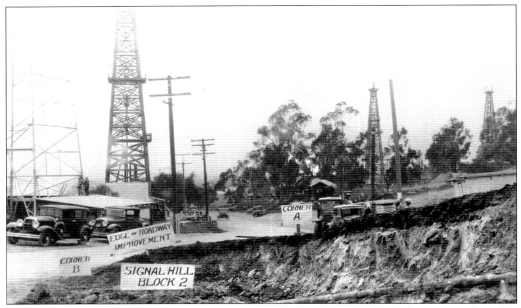

This image shows the intersection of Skyline Drive and Stanley Avenue forking up to the right. The unearthed pipe, with large location signs, seems to indicate that the City of Signal Hill was trying to find out why this pipe was in the wrong place. Even today, the undeveloped parts of the Hill have a crisscross pattern of buried, abandoned pipes, making any new construction in the area a challenge.

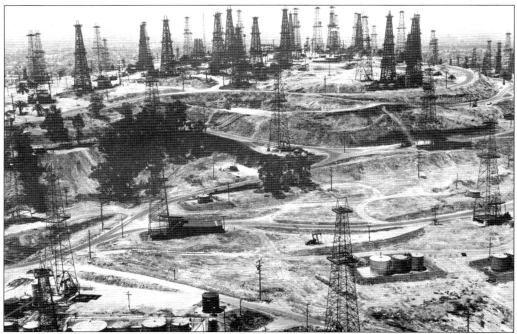

This is an aerial view of the northeast side of the Hill with the oil operations area at bottom left and Panorama Road at top right. The area still remains open space and efforts are being made to preserve some of the last remaining spots on the north slope as a nature conservancy.

It takes a close look to see that this derrick is darkened by the rise of oil within. During the boom years, a well would blow nearly every week.

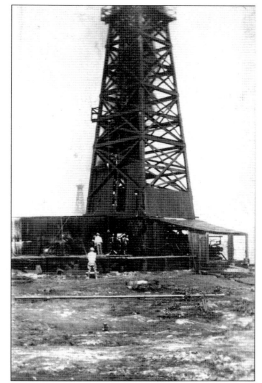

This is a guard shack/office left over from the oil days, run down and becoming a fire hazard. In 1984, it was scheduled for demolition and this last photograph was taken to preserve its memory. Today a person can find many very small homes built for the oil workers still in use.

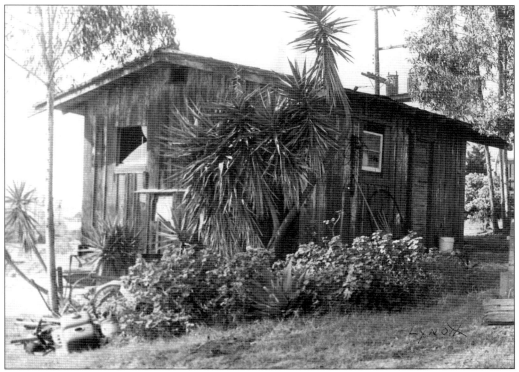

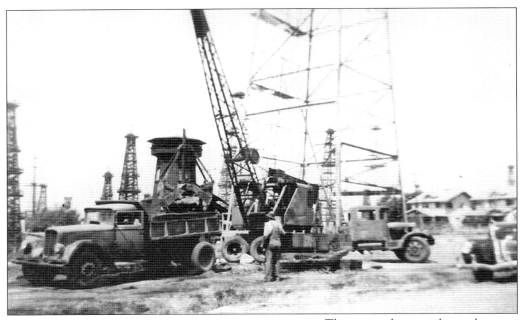

These two photographs, and the bottom image on the next page, are dated August 28, 1945. They all show different angles of a crane working on the oil land surrounding this unusual home with a captain's tower.

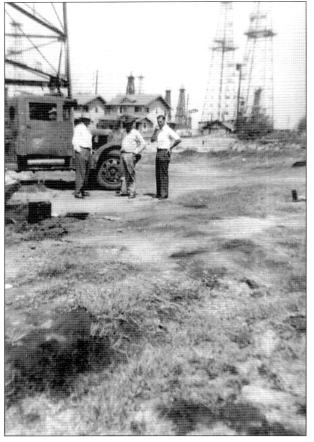

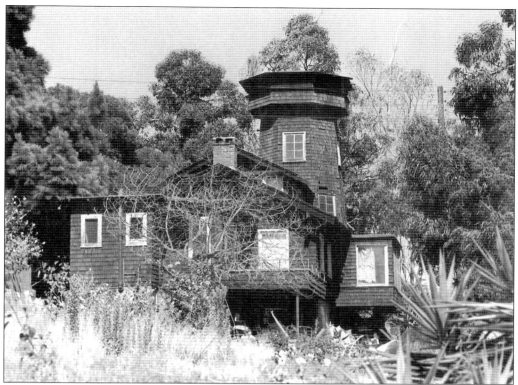

This is a 1970s photograph of the unusual home with a captain's tower. This abode still stands on Gaviota Avenue below Twenty-fifth Street in the Crescent Heights district.

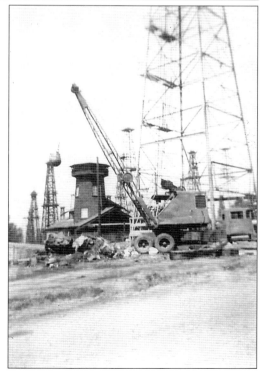

This is another view of the crane owned by Ralph Roseman working on Gaviota Avenue.

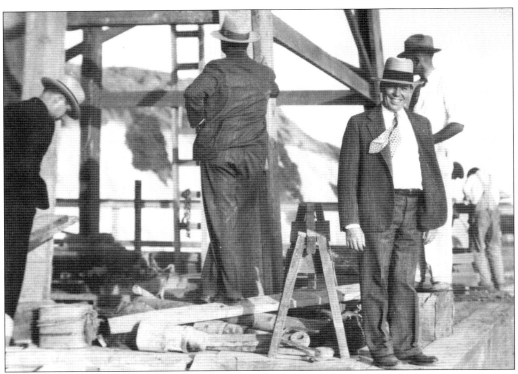

Smiling in the above photograph is Sam Mosher, the founder of Signal Gasoline Company, having a good time inspecting the equipment around a derrick. The image below is another photograph of Sam Mosher (at left), with his father, dressed to impress.

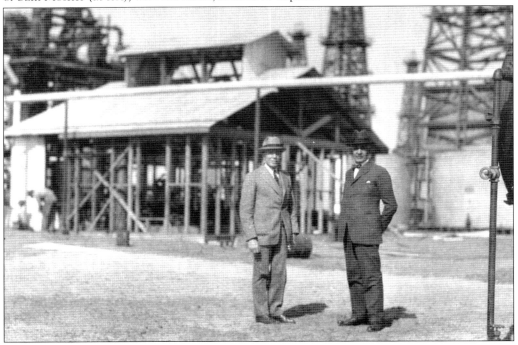

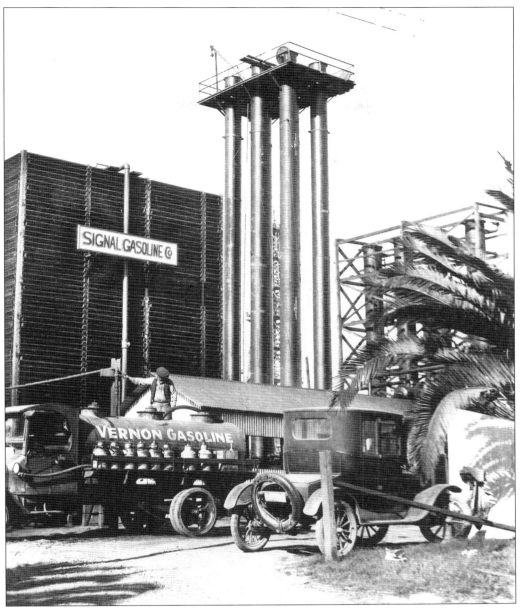
A 1918 chain-driven Mack Truck loads up fuel at Signal Gas refinery.

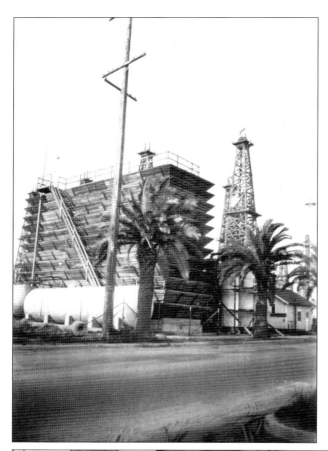

Cooling towers and derricks in the above image were a common roadside scene. The below photograph shows the Signal Oil and Gas Plant No. 2 around 1932 with a work crew resting on the back of this truck, ready to go off to the next job.

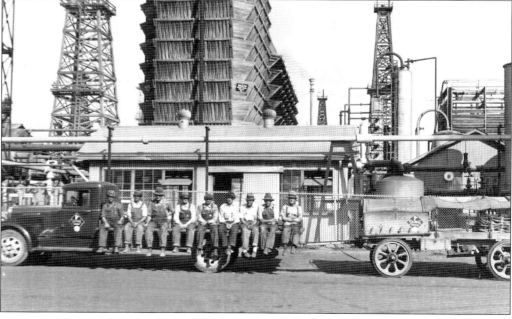

Matthews No. 1 and SS Wortley No. 1 wells are being promoted in these postcard advertisements. Much money was spent to help sell shares in these and other wells owned by the company. Selling of shares in oil wells was a very lucrative business, with many unwitting investors on the East Coast getting cheated out of their savings.

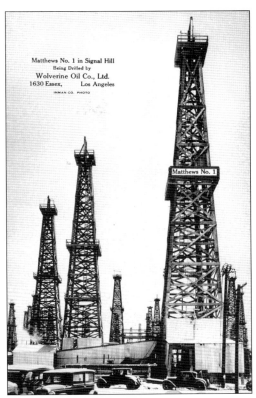

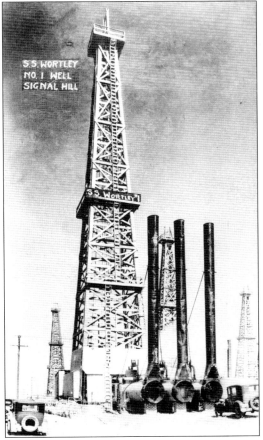

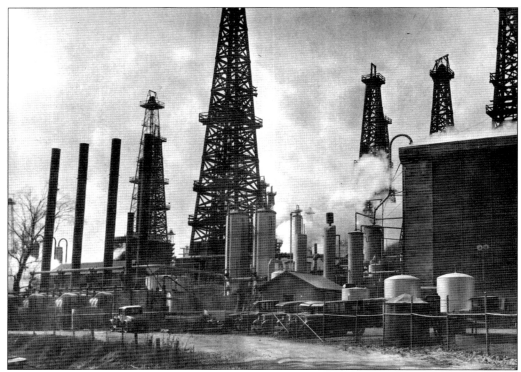

It is a calm, early evening scene at this processing plant with clouds of steam rising to the sky. The oil business has continued on throughout the years.

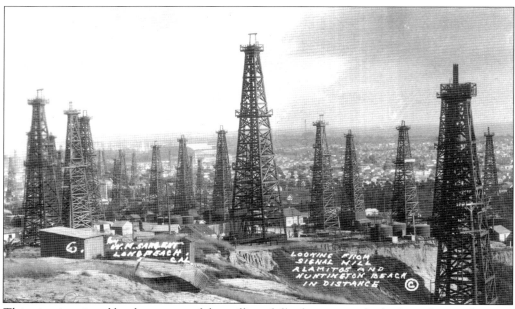

This view is enjoyed by the owners of the million-dollar homes now built along this south rim of Signal Hill. Looking southeast from Skyline Drive, Long Beach's marine stadium can be seen, as well as the Huntington Beach coastline below.

Three
PEOPLE AND EVENTS

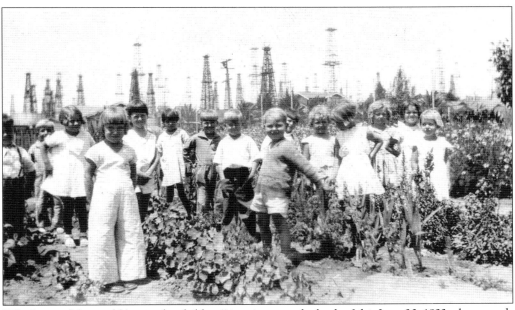

"The hope of the world lies in the children" is written on the back of this June 30, 1933, photograph of the Signal Hill kindergarten class. Life went on as the oil derricks rose up around residents and workers of Signal Hill. Children played and went to school, roughnecks went off to the salons, and many colorful characters and events unfolded in this relatively small town. (Photograph courtesy of Mark Fowle.)

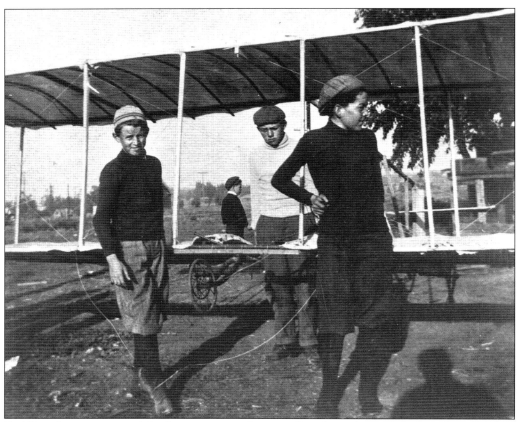

Earl Dougherty was one of the first aviators in the state. Here he is photographed as a boy, standing behind one of his handmade gliders.

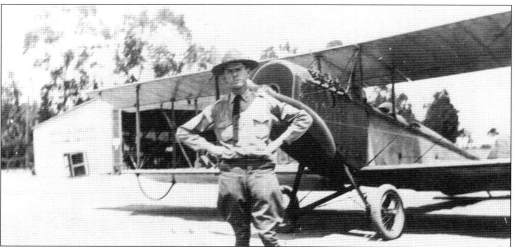

In 1919, Dougherty built his first airstrip along a bean field near what is now Long Beach Boulevard and Bixby Avenue. There he started the first strictly commercial aviation business in the country. This is a photograph of Dougherty standing in front of his "Jenny," which was used to give sightseers thrilling rides above Long Beach and Signal Hill.

This photograph proves that the glider did get off the ground. The slopes of Signal Hill provided an excellent launching pad for these early flights, which also helped launch his aviation career.

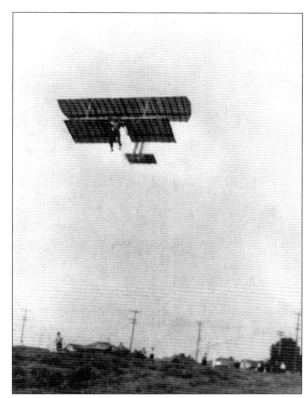

Below is a photograph from what is now Dougherty Field-Long Beach Airport with a view of Signal Hill oil fields in the background.

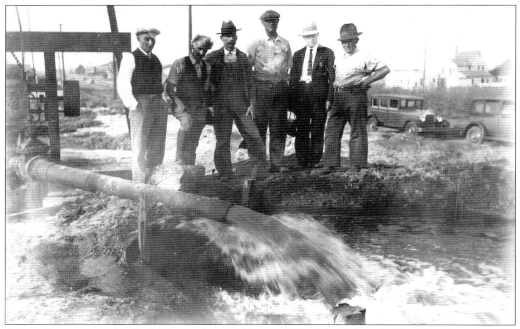

Albert Bustamonte (at far left) stands with Vernon Vore (third from left) while observing the water-pumping station. Both men were council members and founders of Signal Hill.

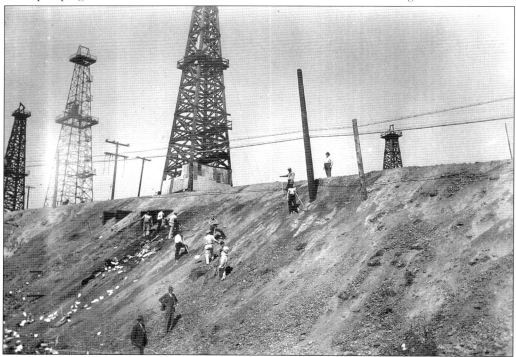

A city crew cleans up the litter on the west side of Cherry Avenue below Burnett Street. This area seemed to be a good dumping spot along the pullout. Further photographs show large debris piles at the bottom of the slope looking more like a dump than a roadside.

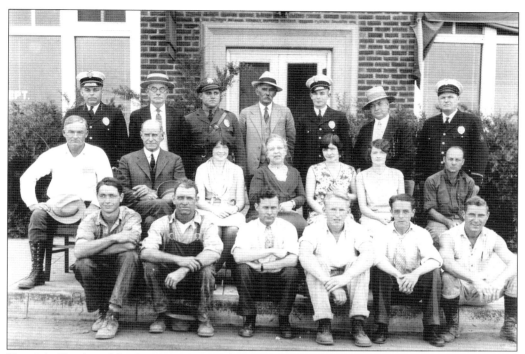

Here Mr. Hinshaw (third row center, standing in the light jacket) joins other early city employees on the steps of city hall. Other photographs of the city hall building on Cherry Avenue and Twenty-first Street, called the Hinshaw Block Building, can be seen later in this book on page 106. (Photograph courtesy of Neena Strichart.)

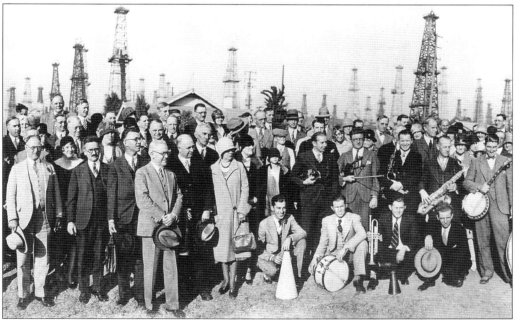

It is not known what prompted this photograph opportunity with the band, but it looks like they were having a good time.

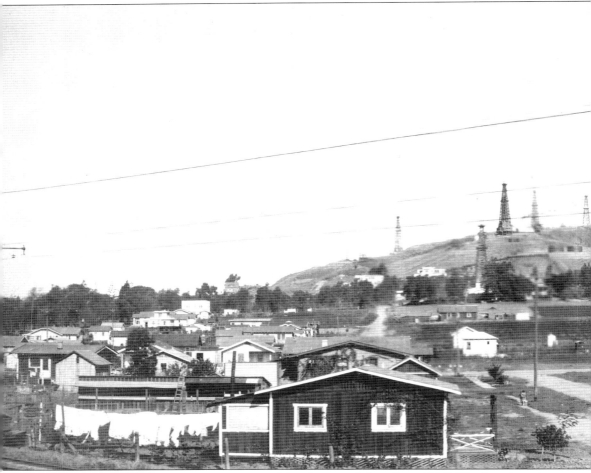
This is one of the most amazing images of the changing life in Signal Hill. The laundry is hung on the clothesline near open fields of crops growing along the dirt roads as a gusher erupts in a

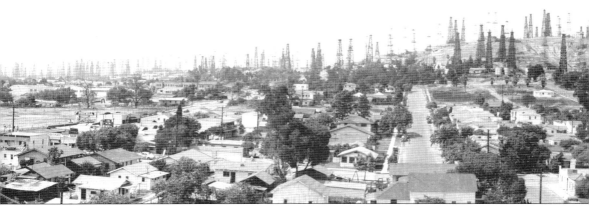
This photograph was taken from the same spot as the one at the top of this page. Note how St. Louis Street jogs at Nineteenth Street and dead-ends above at Twenty-first Street. The homes

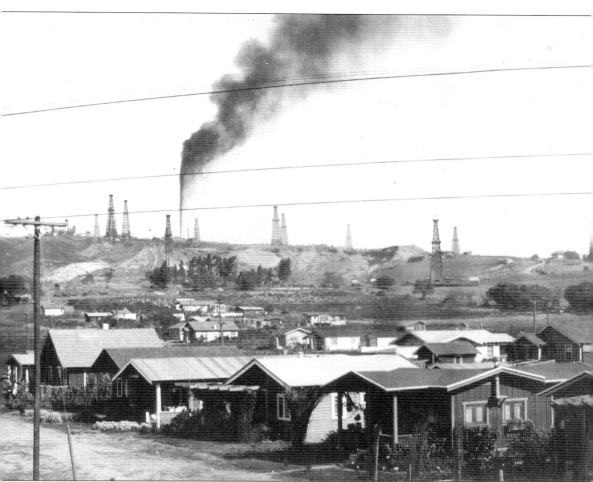
spray of oil hundreds of feet into the air at the top of the Hill.

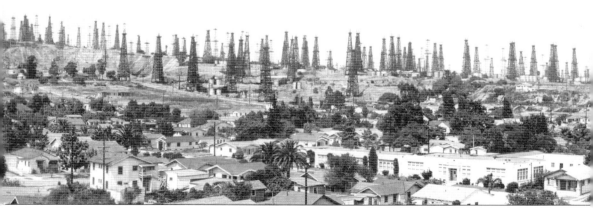
have filled in and the Hill has grown with oil derricks. On pages 102 and 103, there are four more images taken from this spot.

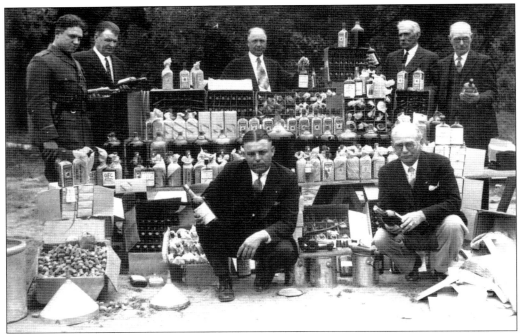

The Signal Hill police display the illegal liquor seized during Prohibition. The city had a reputation as a rowdy place, and this staged photograph may be more for show than a serious crackdown on crime. The City of Signal Hill fathers look over the stash as they appear to reminisce about the "good old days." The image below is of the contraband being destroyed and poured on the ground. The officials are joined by some of the oilmen and colorful characters who seem to be enjoying this scene.

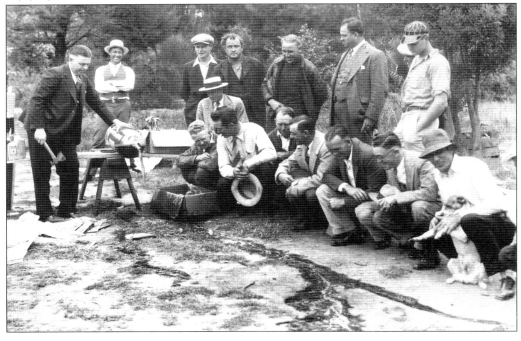

Signal Hill policemen pose for the camera. Pictured, from left to right, are Charles Slanderwort, chief Jack Niblack, Beal ?, and Bud Moon (kneeling).

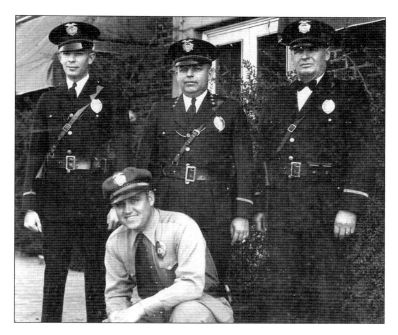

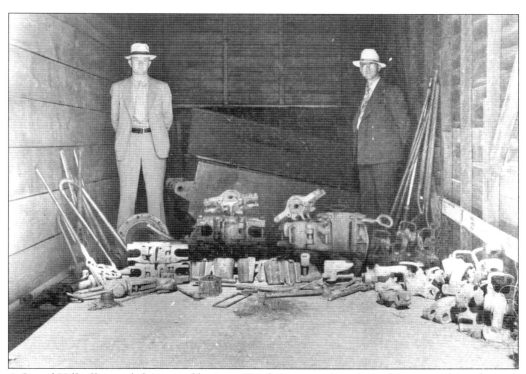

A Signal Hill officer at left is joined by Long Beach inspector Joseph Authier in cracking the case of stolen oil equipment. With the huge amount of activity in oil operations and lots of expensive equipment, crime was sure to follow.

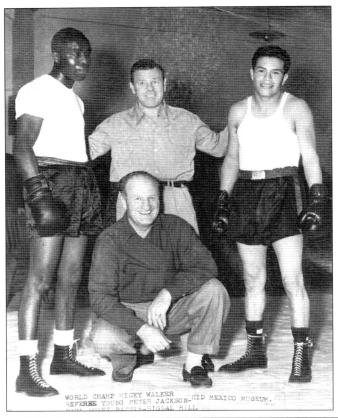

WORLD CHAMP MICKY WALKER
REFEREE YOUNG PETER JACKSON—KID MEXICO MUSEUM.

Having started boxing early, Tod Faulkner was the state bantamweight champ at 14, the welterweight champ at 17, and the middleweight champ at 25. The referee had difficulty pronouncing his name, so he called him "the kid from New Mexico," and later it was shortened it to Kid Mexico. He was a great promoter and political boss who was eventually arrested for gambling, tax evasion, and election fraud. (Photograph courtesy of Neena Strichart.)

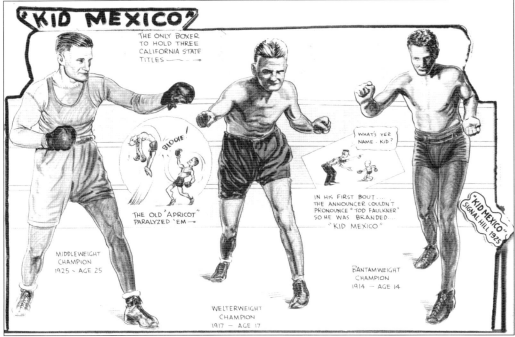

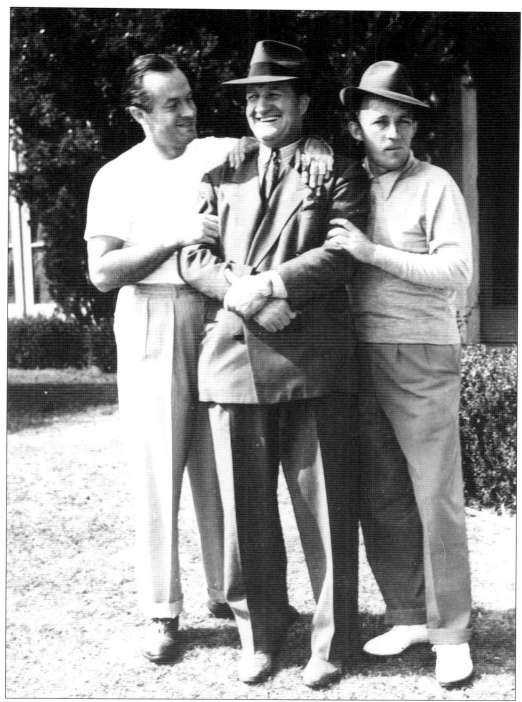

Bob Hope and Bing Crosby join Tod "Kid Mexico" Faulkner on the front lawn. He was well known by many celebrities and didn't mind letting everyone know it. Some of the performers he had entertained at the "kid shows" were Hopalong Cassidy, John Mack Brown, and Jack Dempsey. (Photograph courtesy of Neena Strichart.)

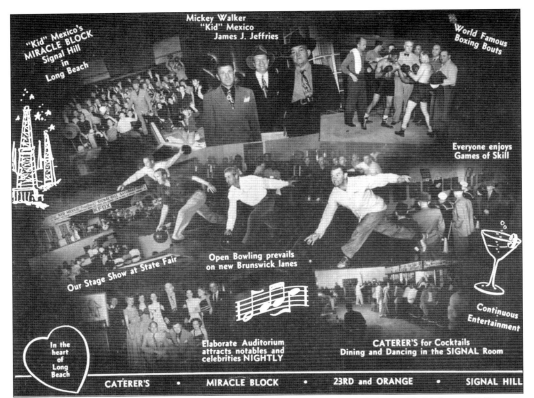

This large promotional postcard reads on the back, "An ex-prize fighter, 'Kid Mexico.'" He was also a former roughneck and driller in the oil wells who saw the recreational potential of Signal Hill and built a beautiful eight-alley bowling center and a unique cocktail lounge and restaurant that housed a glamorous auditorium, a huge dance floor, and a movie house. In the lounge, many oil paintings of movie stars, celebrities, and customers who have made appearances are painted on the ceiling. Kid Mexico also ran a bingo "operation" without police intervention for many years. His parties for the kids helped ingratiate him with the community. Below is a photograph of the street view of the "Miracle Block" along 2259 Orange just above Hill Street.

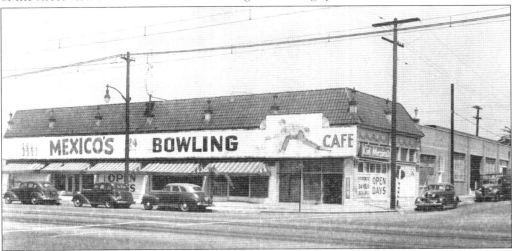

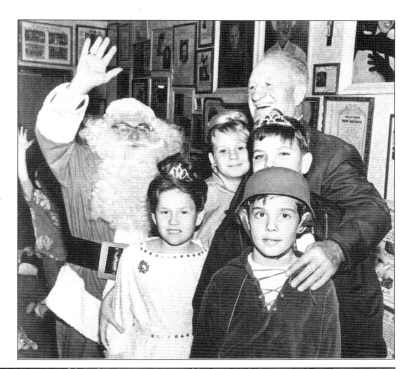

Here is Kid Mexico, also known as the "bingo baron," surrounded by the many photographs and items from his collection as well as the kids he adored. Neena Strichart is pictured between Santa and hugging Kid Mexico. (Photograph courtesy of Neena Strichart.)

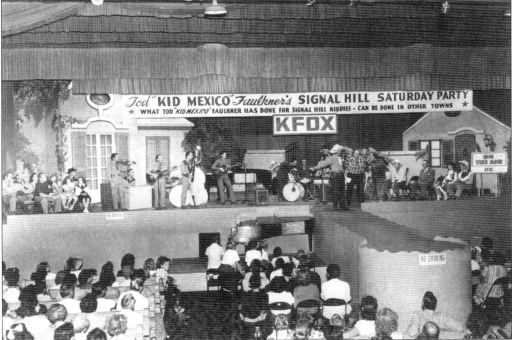

The Kid Mexico Show was broadcast on KFOX from the Los Angeles County Fair with over 10,000 attending the event. Always the showman, the banner overhead reads, "Signal Hill Saturday Party, What Tod 'Kid Mexico' Faulkner has done for Signal Hill Kiddies can be done in other towns."

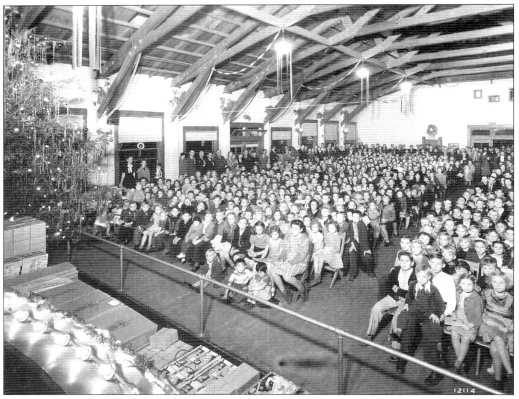

The Shell Club House, on the southeast corner of Hill Street and Obispo Avenue, hosted this very large Christmas party for the kids of Signal Hill.

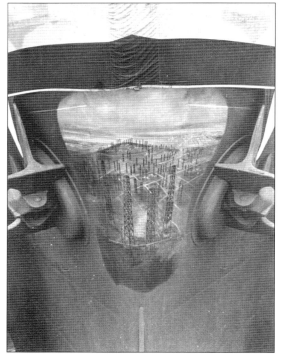

Named after the city of Signal Hill, the SS *Signal Hills*, a 523-foot tanker with a capacity of 140,000 barrels of oil, was launched out of Sausalito, California. Signal Hill's oil production became a critical part of the Pacific campaign during World War II.

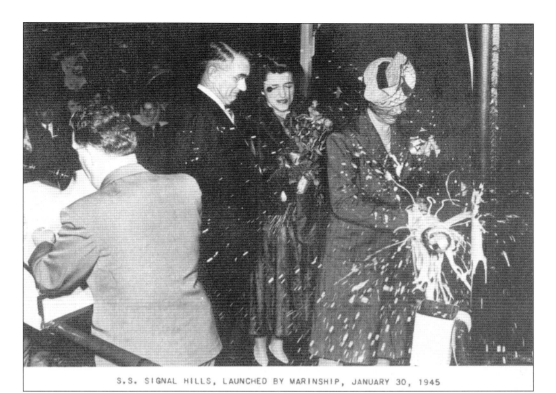

S.S. SIGNAL HILLS, LAUNCHED BY MARINSHIP, JANUARY 30, 1945

Mrs. Clarence W. Mayhew of San Francisco christened the SS *Signal Hills* on January 30, 1945. Mayhew is the wife of the purchasing agent of the Marine Shipbuilding Corporation. A few dignitaries from Signal Hill attended the christening. The image below shows the bow of ship.

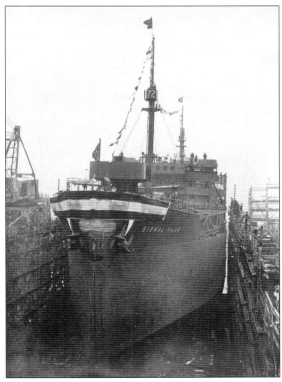

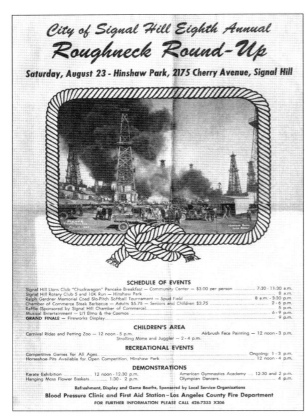

The City of Signal Hill held many events in town, and two of the more memorable were the Roughneck Roundup (above) and *Fiesta de Ora*, or Festival of Oil. In those days, everyone would show up to have a good time with pancake breakfasts, barbecues, picnics, dances, and fireworks displays. Many of these events were partially underwritten by the oil companies.

Everyone loves a parade. Here councilman Joe Denni, a descendant of the founding Denni family, is dressed up on his horse.

Being such a small town, Signal Hill shares many organizations and events with the surrounding City of Long Beach. Even today, the schools in Signal Hill are operated by the Long Beach School district. This press photograph shows the kids on a fire truck given to the local YMCA.

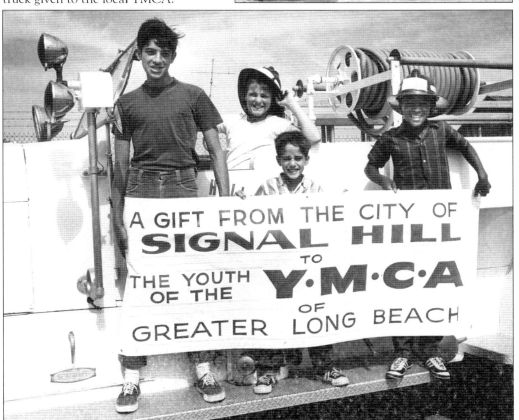

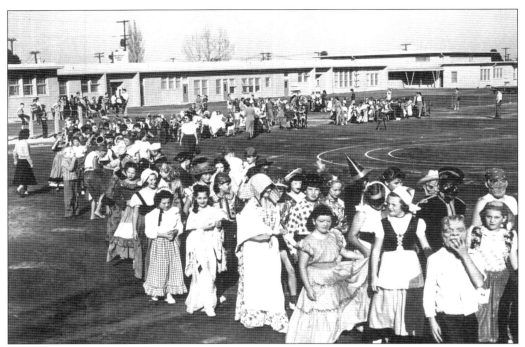

The kids from Burroughs Elementary enjoy a Halloween parade across school grounds (above) and present the Fall Carnival (below).

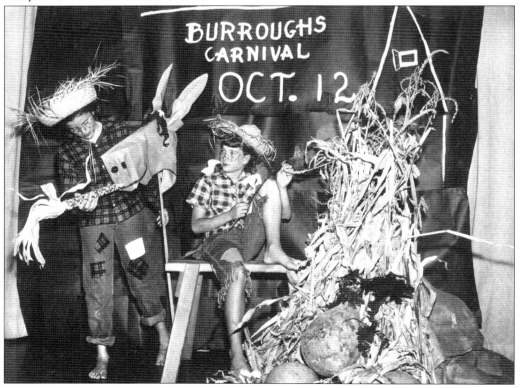

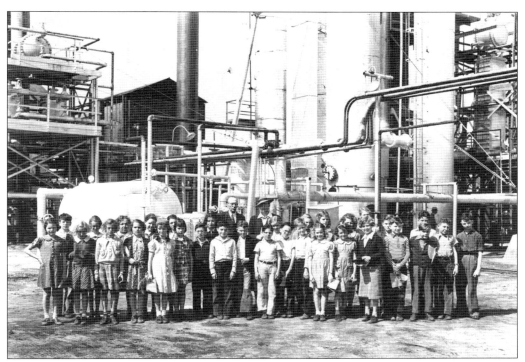

A field trip to the local refinery gave these children the opportunity to learn about what was going on in the facilities surrounding their schools. These kids from the 1950s stand tall and orderly for the photograph, but the below 1970s image of a park event shows the changes in styles and attitudes during the 20-year gap.

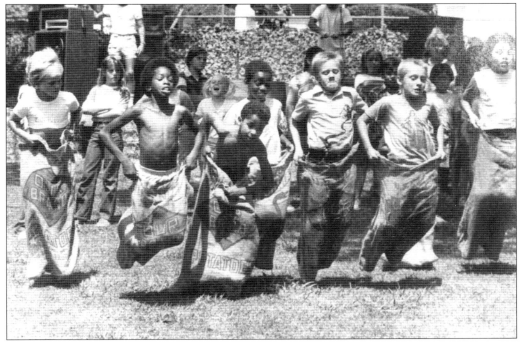

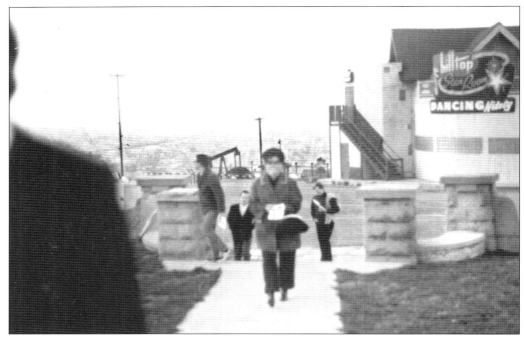

When speaking of Signal Hill with natives, one thing almost always comes up: "I remember the great times at the Hilltop Star Room." This landmark stood along the rim of Skyline Drive and Hill Street where Sunset View Park is now located. The original building was actually the Denni carriage house, which was moved to this location to make room for the oil wells (see page 23). The steps in the foreground are the original entry to the Denni mansion, where luxury homes now take advantage of this legendary view.

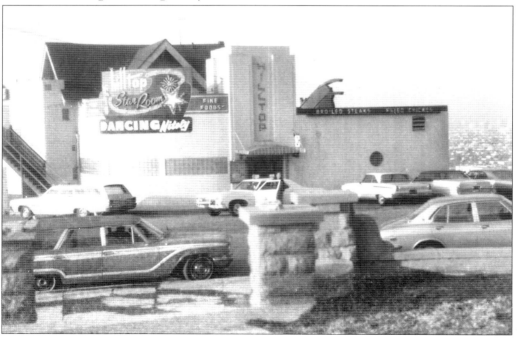

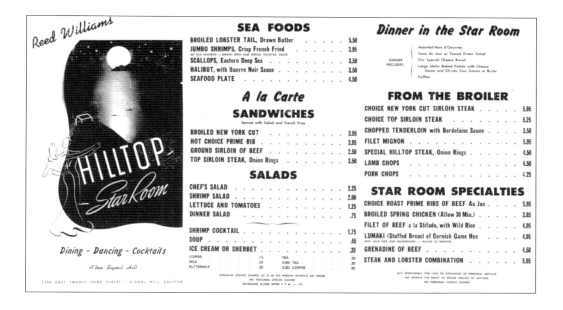

The menu above may bring back some memories to those who dined at the Star Room. If only a meal could still be bought at those prices. Many did not bother taking their dates to the restaurant, but rather parked along the hillside roads for a quiet time reflecting on the nighttime views. Maybe that is why this Boy Scout troop was needed to help clean up the trash (below). Today this area features beautifully landscaped parks and gated hilltop homes. A few still try to take an opportunity to park with their dates, only now the neighbors are watching and calling the police.

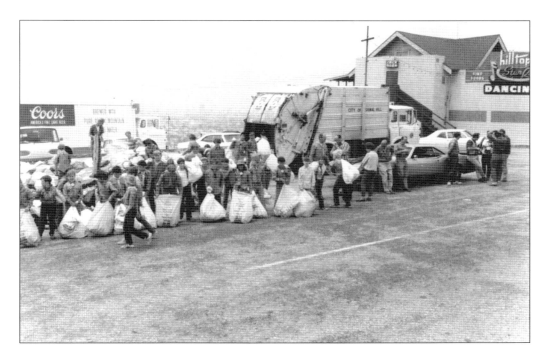

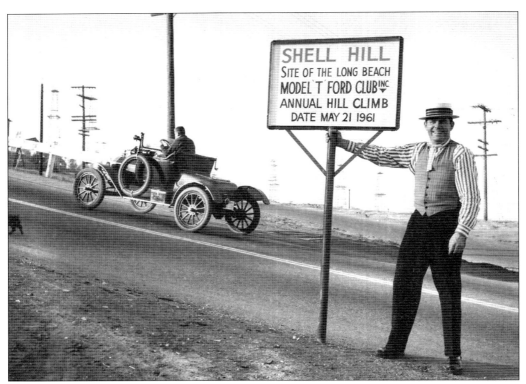

The steep slope on Hill Street, rising up to Temple Avenue, was often used by automobile makers to test the hill-climbing ability of their vehicles even as far back as the 1920s. Building on that tradition, the Long Beach Model T Club recreated this very popular event.

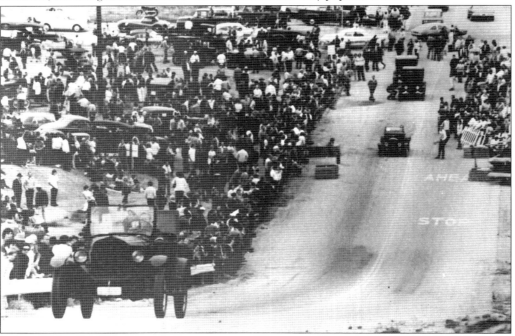

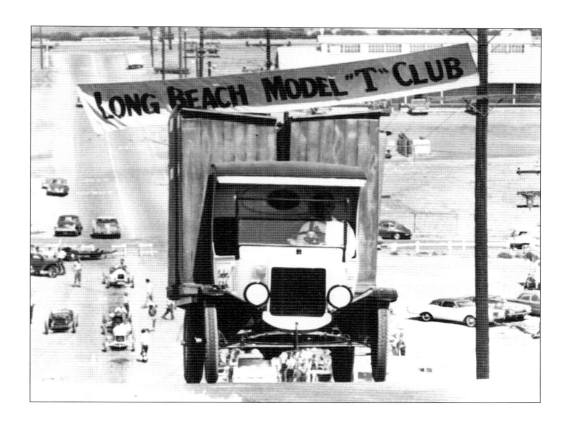

The truck owner pictured above is a bit of a show-off as he tries to race with a load of outhouses on the bed. As this steep road became better known, skateboarders wanted to push their limits and a short-lived competition took place going in the other direction, down the slope (below). Organizers brought the top talent in this new sport to race down the Hill with ever-more-complicated devices. The inevitable accidents of this 1970s sport shut down the event.

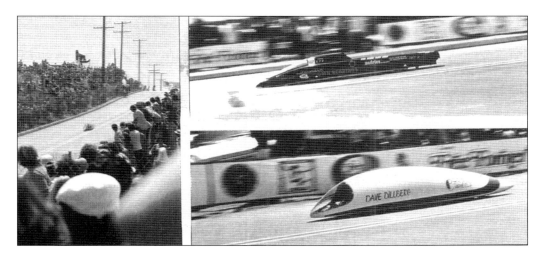

This southwest view of the intersection of Cherry Avenue and Twenty-first Street shows the first few small buildings of the military academy. Below, some of the cadets are pictured marching smartly with the nation's flag.

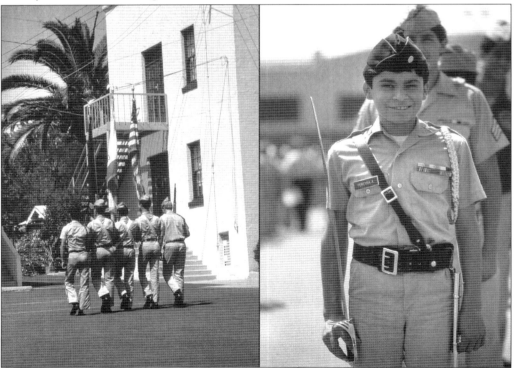

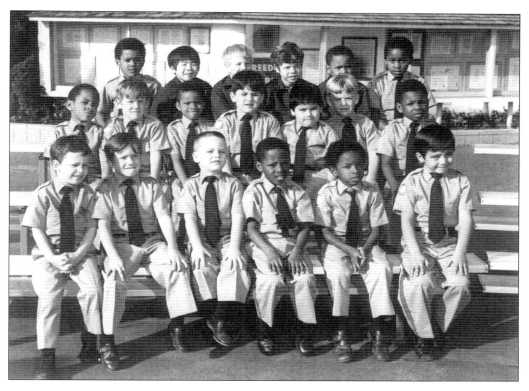

These young students smile for a class photograph (above) or are watching attentively the passing marching drum corps (below). Many successful businessman in the community today learned discipline and teamwork at this fine academy.

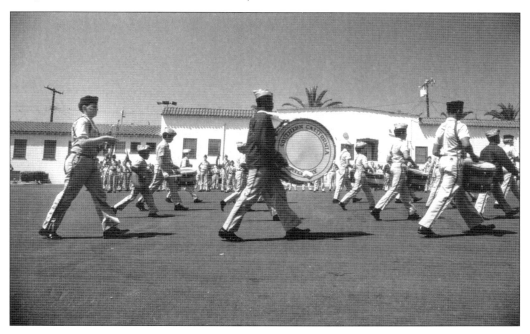

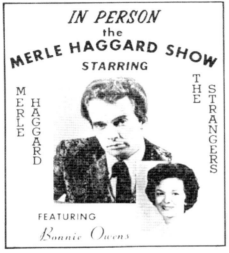

Bonnie Price's Foothill Club in small-time Signal Hill brought some very big names to entertain, such as Johnny Cash, Patsy Cline, Jerry Lee Lewis, and Tanya Tucker. Above is a Merle Haggard poster and below is a ticket to a Willie Nelson concert.

Four
FIRES AND DISASTERS

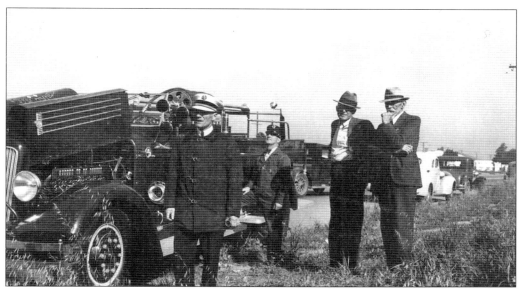

Pumping oil from the ground is a dangerous endeavor. Large timber towers soaked in oil and overworked roughnecks working in close quarters create the setting where just one mistake can lead to a fire or explosion. It is actually surprising that more fires and disasters did not occur. The following pages document the more notable fires and explosions, including a jet plane crash. Above is fire chief Adolph Feil standing beside his Seagrave fire truck, arriving at the scene to size up the situation.

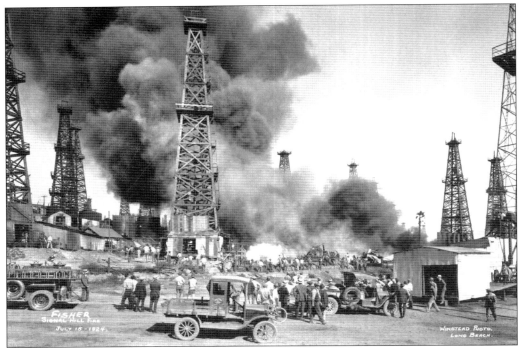

High concentrations of natural gas posed a constant danger to oilmen developing the Signal Hill fields and made blowouts and fires common occurrences. These are images from the July 15, 1924, Fisher Fire. Like in most of these photographs, the crowds and the cars they came in on are as interesting as the event.

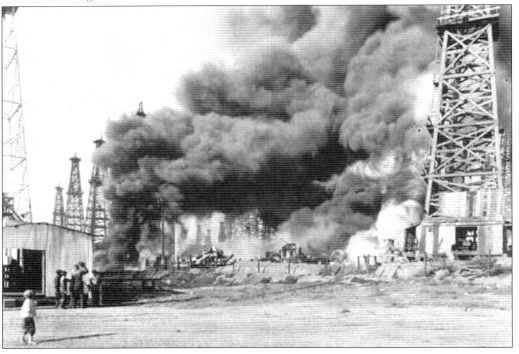

Here is an extraordinary shot of a collapsing wooden derrick with children scrambling and the adults calmly looking on.

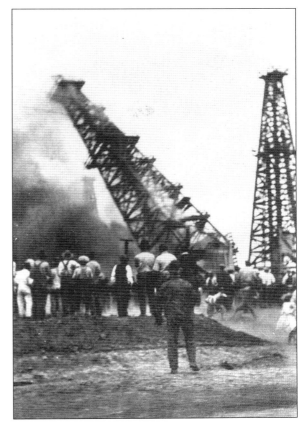

Firemen rescue an injured man from the twisted metal and debris of a gas explosion. This photograph, oddly enough, was from a postcard.

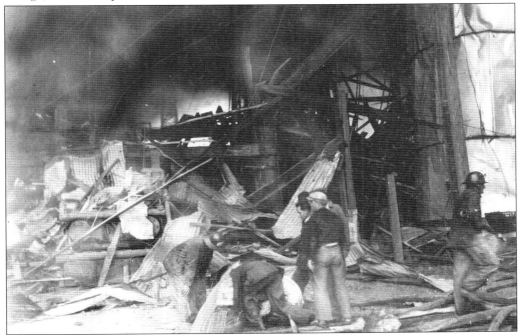

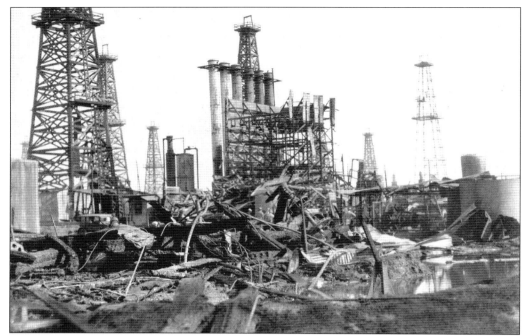

Pictured here is the wreckage caused by an explosion of a small refining plant in the midst of the forest of oil derricks. One man was seriously injured, and four oil derricks and one small refinery unit were destroyed.

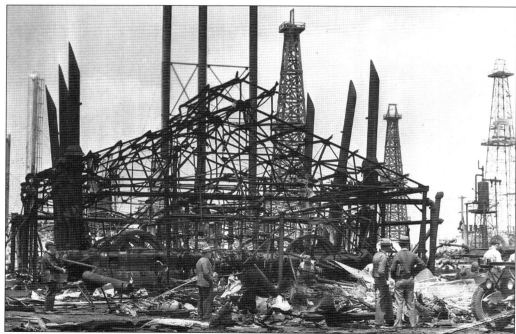

A blast of fumes at the Richfield Meandor Plant near Lime Avenue and Twenty-seventh Street on June 2, 1933, resulted in eight deaths and damage estimated at $250,000. The explosion and fire caused damage to a number of nearby residential structures and destroyed several nearby derricks.

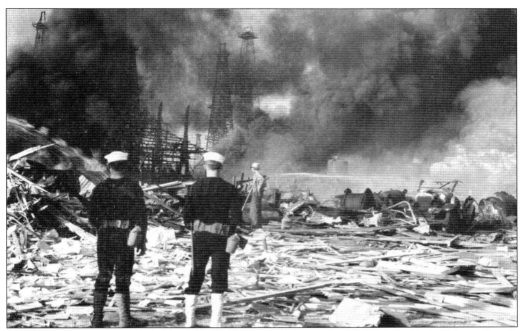

The above photograph has been credited as being the aftermath of the March 10, 1933, Long Beach earthquake because of the navy police standing by. Oil lines were broken and oil flowed down Atlantic Avenue for five hours after the quake, but the rest of the Hill was not greatly affected. The below photograph is of the compressor plant fire three months later on June 2.

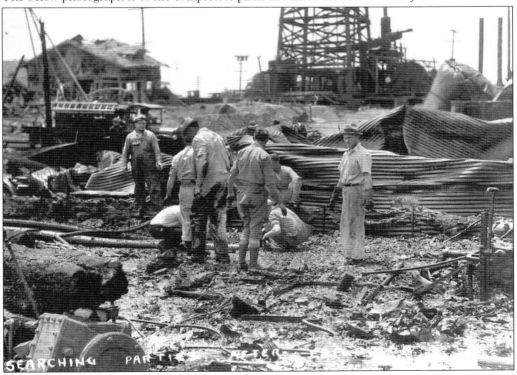

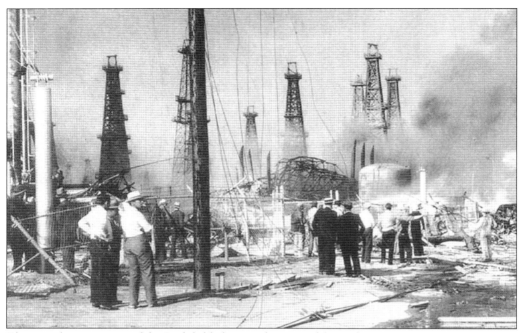

The next four pages are of the Richfield plant explosion and fire. Like most of these events, people came from all around to see what was going on.

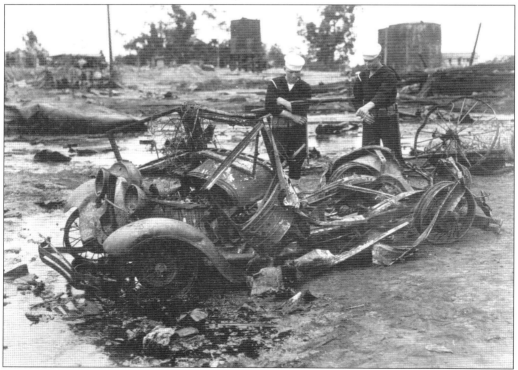

Maybe these are the same sailors from the photograph on page 83, checking out what it might take to get this car back on the road. (Photograph courtesy of Mark Fowle.)

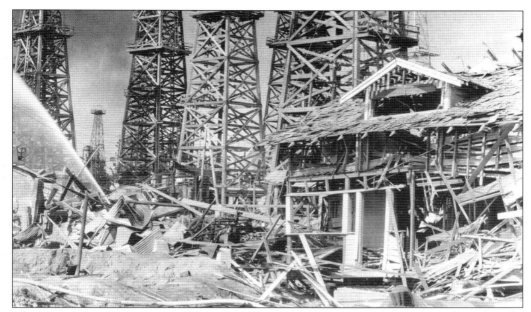
The homeowners here must have thought they were lucky to escape the Long Beach earthquake without any damage, but when they came home they realized they weren't as lucky as they thought. (Photograph courtesy of Mark Fowle.)

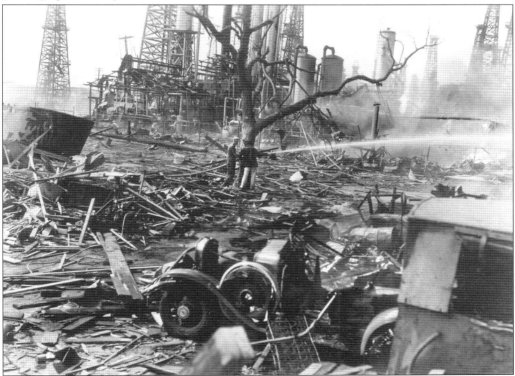
This is another scene of the carnage of the Richfield explosion. (Photograph courtesy of Mark Fowle.)

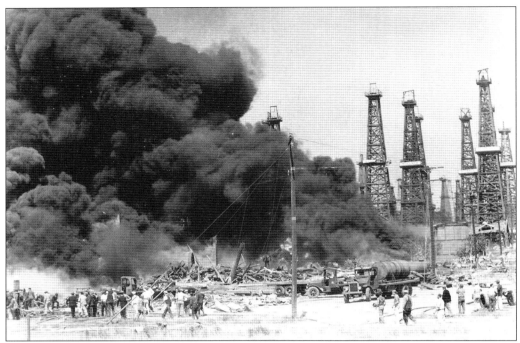

These two photographs show how close this refinery was to the homes. The oil wells were on one side, and residents on the other. This is just west of the Sunnyside Cemetery; the homes in the foreground are in Long Beach. (Photograph courtesy of Mark Fowle.)

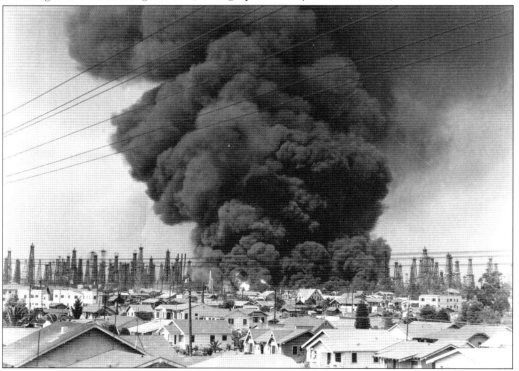

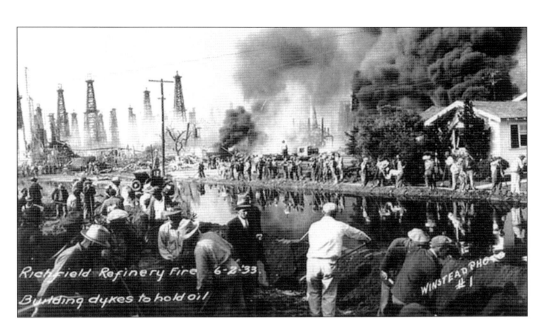

When an oil well gushed, or in this case when a refinery storage tank broke, the men took to the streets with shovels to contain the flow of oil. This fairly tall dike, for being hastily built, is holding a lot of oil.

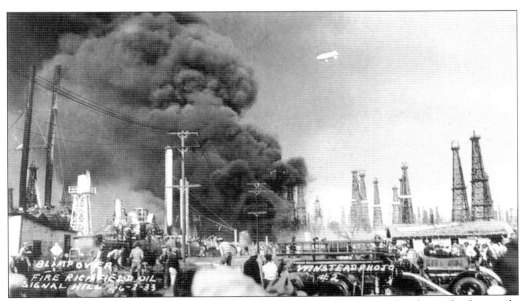

The blimp overhead has a great vantage point for the action. This image also shows the fire truck, men building the dike, and the remaining parts of the facility all in one shot.

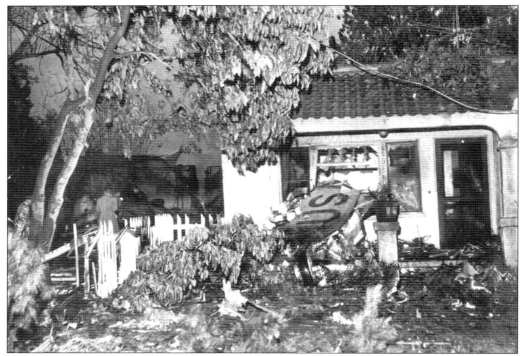

On January 12, 1954, a pilot lost control of his U.S. Navy F-86 jet trying to land a Long Beach Airport and crashed at Nineteenth Street and Raymond Avenue, demolishing four homes. The pilot was killed along with five residents, including young "Spud" Shoup, who is honored with his name at Signal Hill Park's Spud Field.

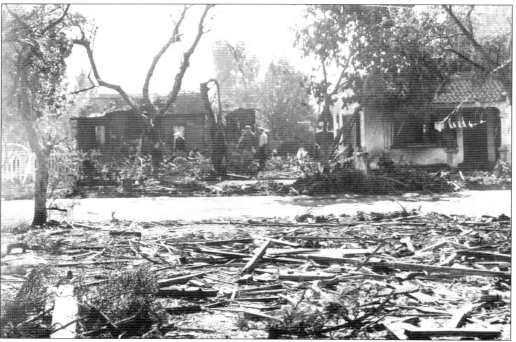

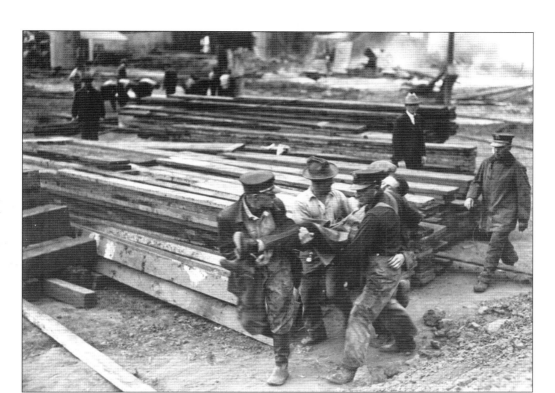

Local firemen, covered in soot, rescue this man. Working in the oil field was dangerous work, but having these noble men come to the rescue must have been just as reassuring then as it is now. (Photograph courtesy of County of Los Angeles Fire Museum.)

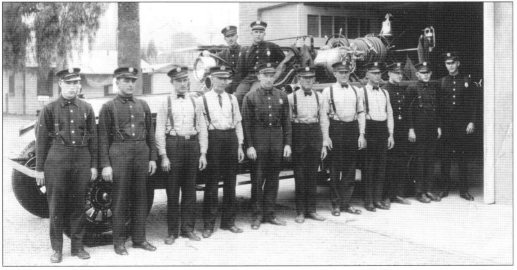

Los Angeles County originally ran the first fire department in Signal Hill until the City of Signal Hill incorporated and was able to form its own department. Many of these first firefighters stayed on to join the new department, most notably the seventh man from the left, who would become chief, as seen in later photographs. (Photograph courtesy of retired Los Angeles County fire captain Theodore Schreider.)

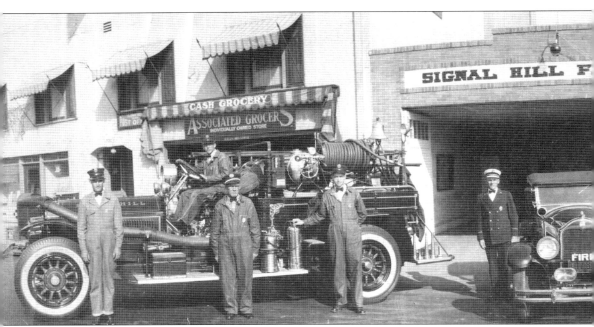

This is the same firehouse as on page 89, pictured here after it changed over to the City of Signal Hill. The Signal Hill Fire Department was located on the east side of Cherry Avenue, just north of Nineteenth Street (later the site of The Foothill Club). At left is a 1924 American LaFrance, which was 1 of the first 15 Los Angeles County fire engines. It features a mid-mounted pump that requires a separate water supply. The County of Los Angeles Fire Museum Association has

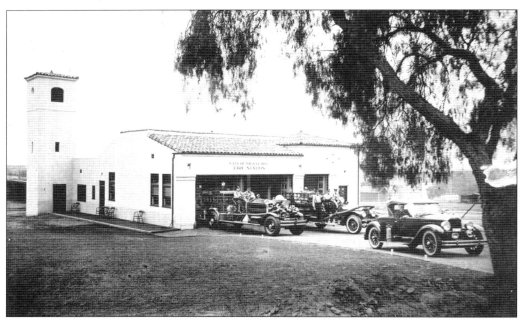

This is the new fire station on Hill Street, west of city hall. Note that they still had the same equipment as the photographs at the old station on Cherry Avenue. (Photograph courtesy of County of Los Angeles Fire Museum.)

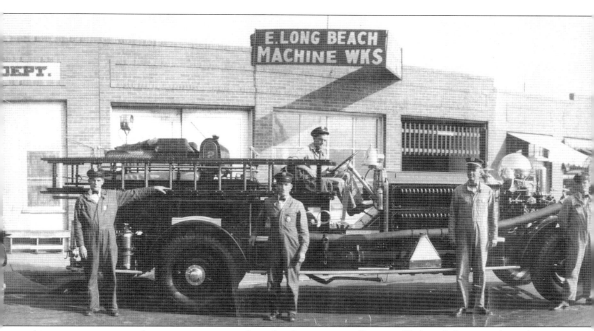

this rig in storage with a restoration pending. In the center is Captain Feil with his car. At right is a 1927 Ahrens Fox, considered the Rolls Royce of fire engines, with a front-mounted spherical pump and equalizer ball. The new oil-rich City of Signal Hill could afford the best equipment. (Photograph courtesy of Neena Strichart.)

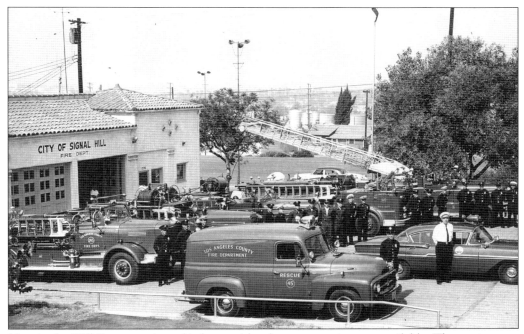

Here is the Hill Street station a bit later, with a lot more equipment available. The station was closed and converted into the Signal Hill Library in 1978.

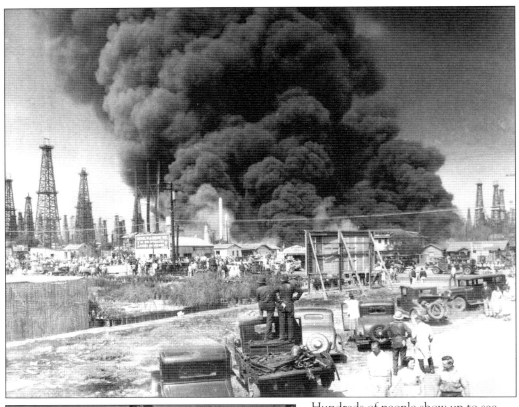

Hundreds of people show up to see what is going on as the fire crews try to contain this blaze. Since it took a lot of time for the oil to burn out, these events turned into attractions. (Photograph courtesy of Mark Fowle.)

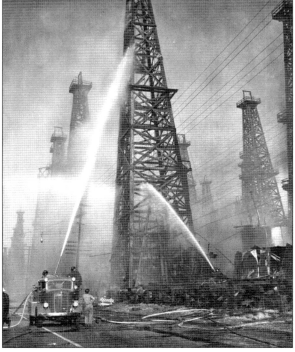

Not all the fires were spectacular. Occasionally a single well would catch ablaze and the fire department would extinguish it before it got out of control. These oil-soaked wooden derricks were real firetraps.

This fireman takes a well-earned rest in the midst of the carnage left by the Hancock Refinery Fire (shown on the next seven pages).

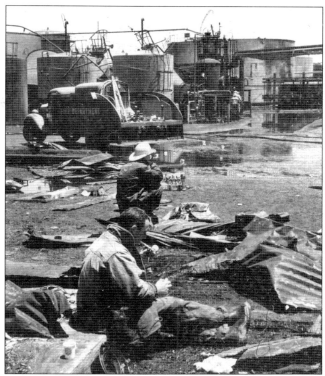

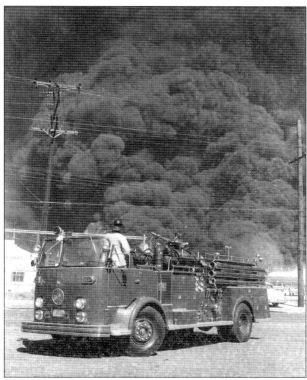

The fire trucks arrived from all over the southland in response to the Hancock Refinery Fire on May 22, 1958.

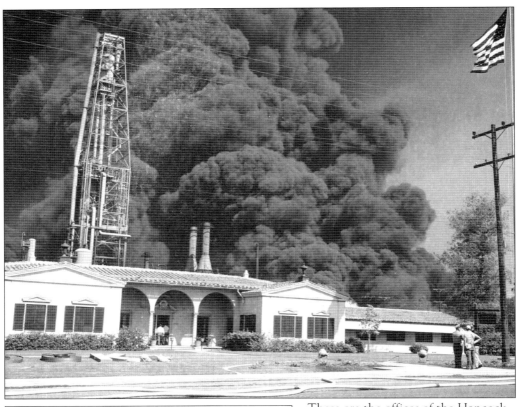

These are the offices of the Hancock Oil Company on the east side of Junipero Avenue between Spring and Willow Streets. This is an early photograph of the May 22, 1958 Hancock Refinery Fire. It started around 2 p.m. when steam built up and burst the top of a storage tank and the frothing oil overflowed the tank and surrounding retaining dike.

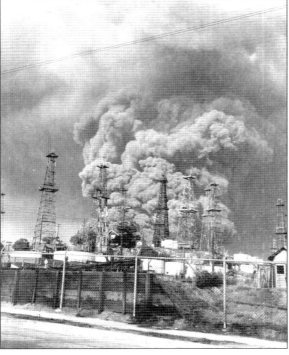

An unknown source ignited the oil froth and started the chain reaction fire that spread across the refinery and burned for two days.

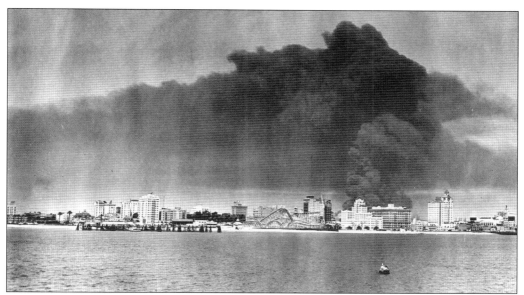

This photograph taken from the Long Beach Harbor shows the skyline of Long Beach, the Pike rollercoaster, and the dramatic smoke billowing into the sky.

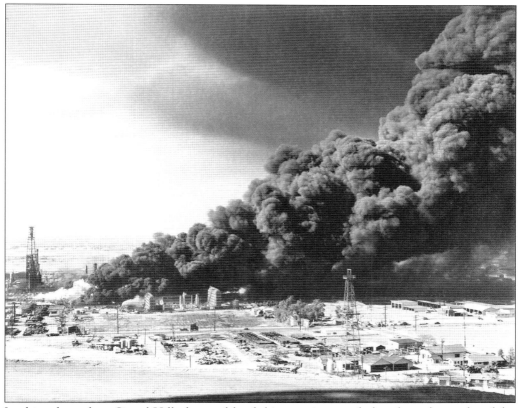

Looking down from Signal Hill, the southland skies continue to darken from the smoke of the Hancock Refinery Fire.

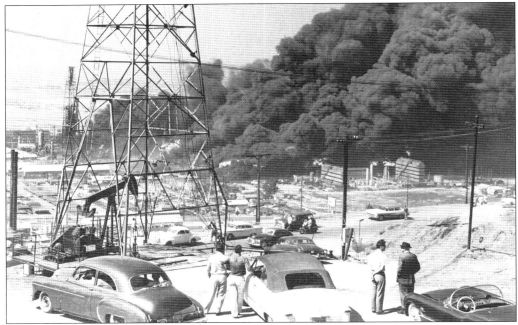

Residents living in Signal Hill at the time remember that the fire clogged the sky with smoke and soot fell continuously. As pictured here, many sought the good views along Panorama Drive on the hilltop of Signal Hill to watch the events unfold.

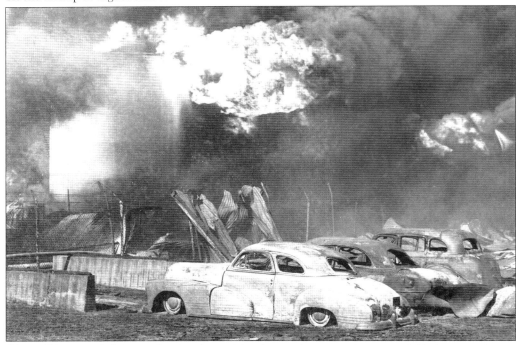

About 50 automobiles were lost in the parking lot, and one employee was killed attempting to rescue his car. A second employee was lost trying to get one last thing done in the path of the fire but was overcome by the spreading flames.

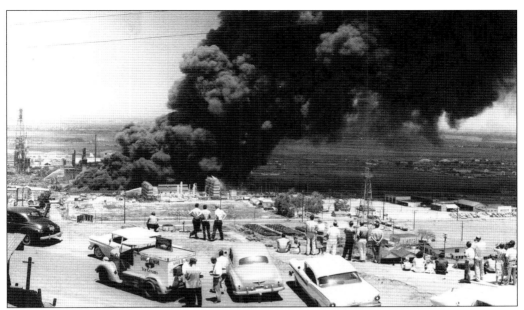

Area residents gathered on the hilltop to watch the events. Even the Good Humor truck stopped by for what looks more like a good business opportunity than a viewing experience.

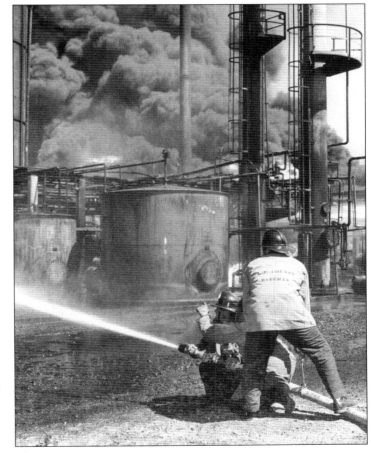

Fire departments involved in fighting this fire included Signal Hill, Long Beach, Los Angeles County, Vernon, the Long Beach Air Force Base at the airport, and the navy. Eighteen firefighters suffered minor injuries.

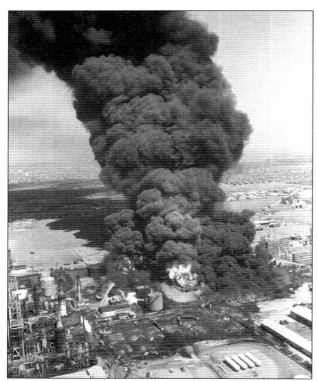

This aerial photograph, taken on the second day of the fire, shows the path the frothing took as it escaped the tanks.

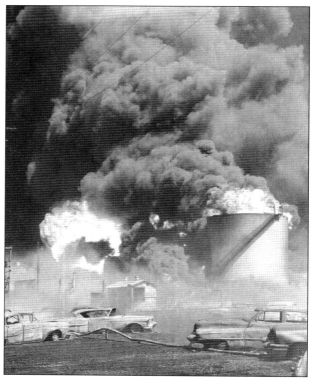

This fire took its toll. As the second largest refinery fire in the nation at the time, its losses included two Hancock employees and over $6.5 million in damage.

The fire spread across approximately 15 acres and destroyed hundreds of thousands of gallons of crude oil.

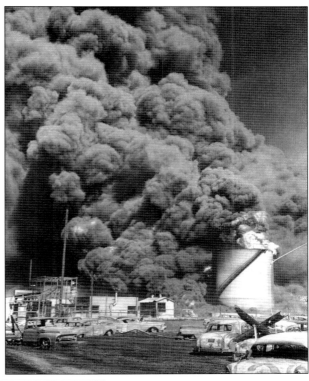

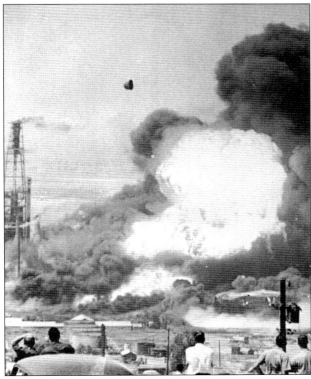

The top half of a 10-by-24-foot-high amyl nitrate tank exploded and shot across the sky, as witnessed from this safe distance on the hillside.

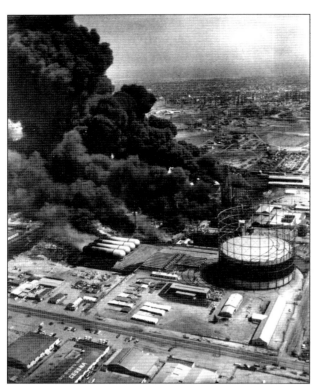

Thankfully, the 10-million-cubic-foot natural-gas tank remained intact and was not affected by the surrounding fire. This tank was a recognizable landmark along the side of the 405 freeway until it was dismantled.

Firefighters from seven departments saw long hours of duty during the Hancock fire. Almost 14 million gallons of water were consumed during the efforts to extinguish the fire.

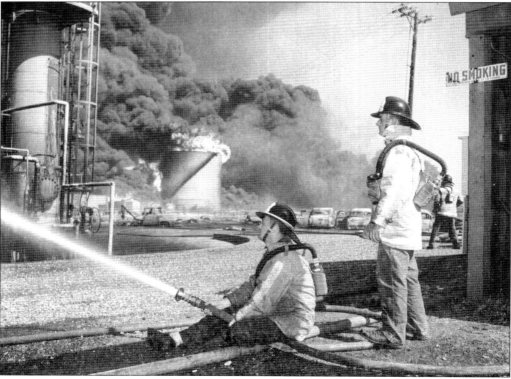

Five
Homes and Street Views

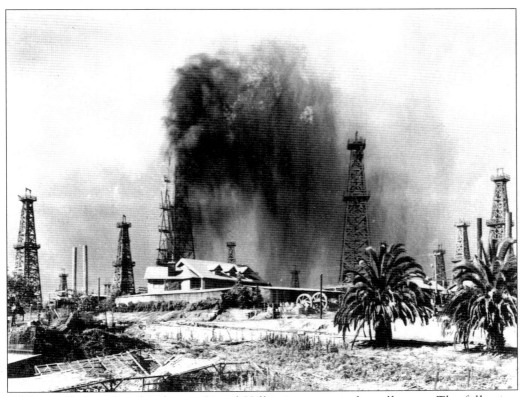

Without all the oil and industry, Signal Hill is just a typical small town. The following images of neighborhoods and street views do have references to oil, but it's the everyday life that is documented.

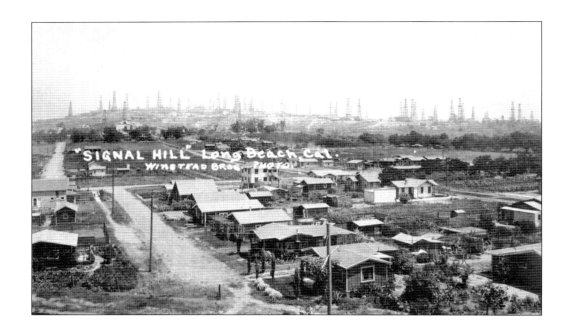

This amazing series of photographs document the same location over the years. The above view is from the 1920s. On pages 58 and 59 there are two panoramas from this same location. The below image is from the 1930s. For reference, the street shown is St. Louis, which jogs at Nineteenth Street and dead-ends at the top at Twentieth Street. Pacific Coast Highway would be just behind the camera.

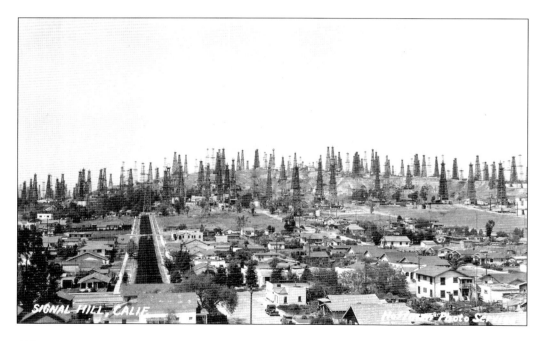

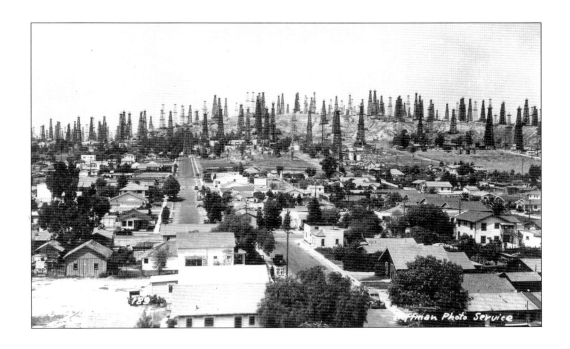

The above image is dated March 17, 1942, and is from around the same time as the image below. It is only logical that an abandoned derrick or platform drew so many photographers to this location. This is the southwest neighborhood of Signal Hill.

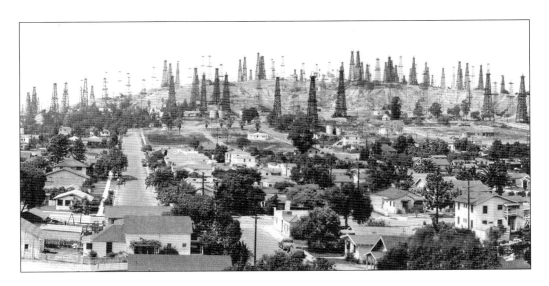

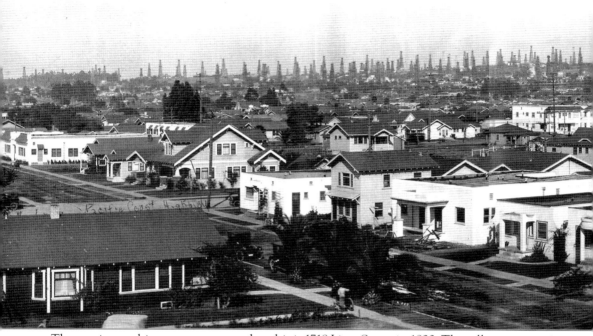

The caption to this panorama states that this is 1718 Lime Street in 1923. The tall apartments in the center of the photograph, peeking over the foreground, are on Pacific Coast Highway. Many large homes can be seen on the south slope of Signal Hill. Note how far off the left side of the

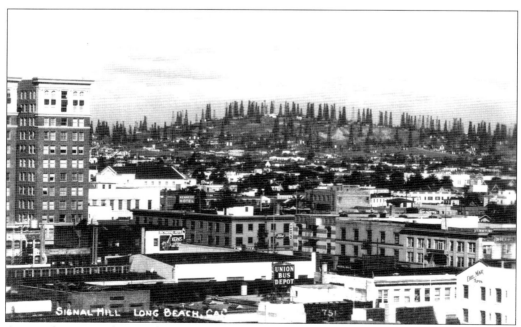

A view from a rooftop in downtown Long Beach gives a great perspective of the spines of "Porcupine Hill."

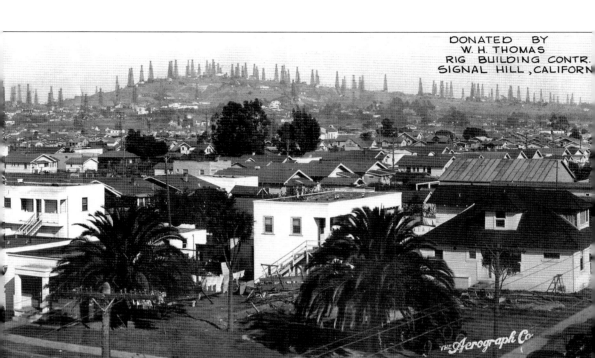

hill the oil derricks extend beyond the current borders of Signal Hill. It would be interesting to drive up and down these streets to see how many of these homes are still there.

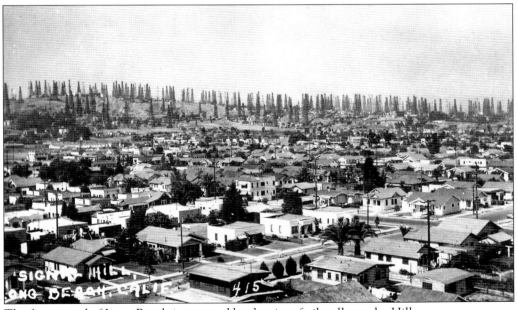

The foreground of Long Beach is crowned by the rim of oil wells on the Hill.

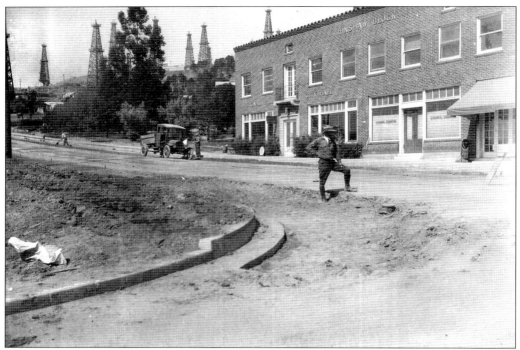

The Hinshaw Block Building, at the corner of Twenty-first Street and Cherry Avenue, housed Signal Hill City Hall. Street improvements, curbs, and resurfacing were underway with a Model T dump truck along the curb in the image above. Below is a direct north view of Cherry Avenue. The tree at left is where Signal Hill Park (Hinshaw Park) now sits.

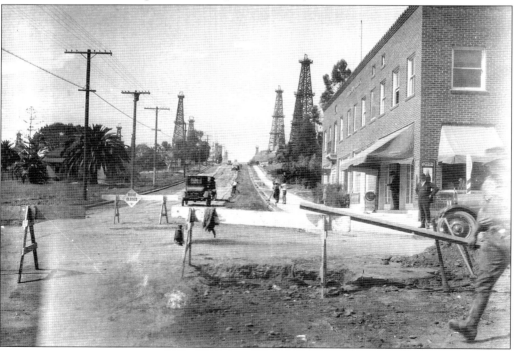

This city worker was able to get into both images. In the above photograph, note the amount of open area and the cluster of small homes in what is now a large condominium complex. This photograph is dated November 1926.

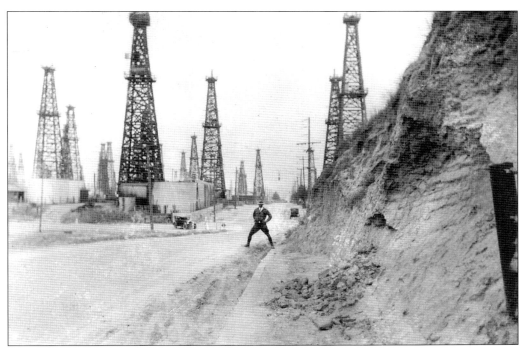

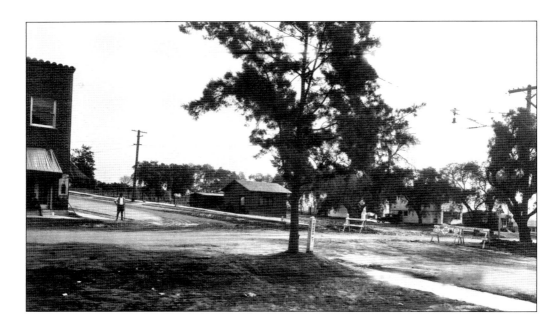

This is the same intersection as the images on page 106, but this time it is looking to the southeast. The above image is from 1920s, while below is from the 1970s with the old city hall building still standing across from the new church.

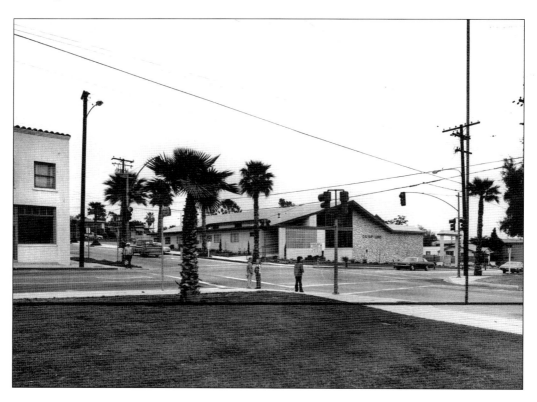

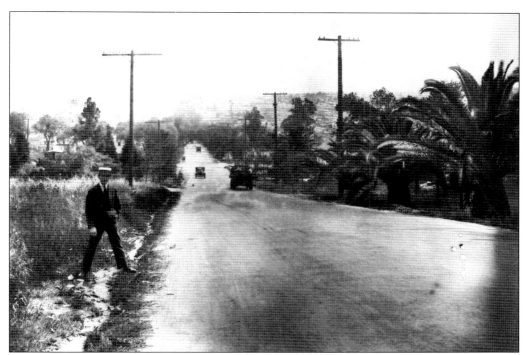

Here are two photographs of Hill Street looking south on Cherry Avenue toward the ocean. The above image is a 1920s view, without curbs or sidewalks, and the below image is of the area after widening and improvements.

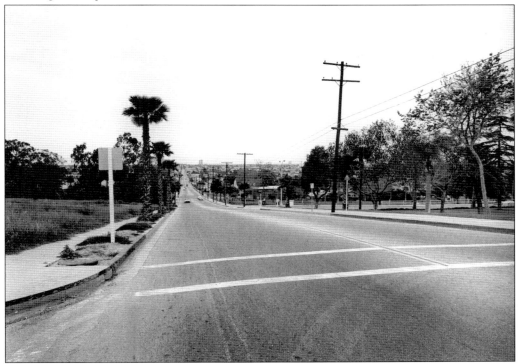

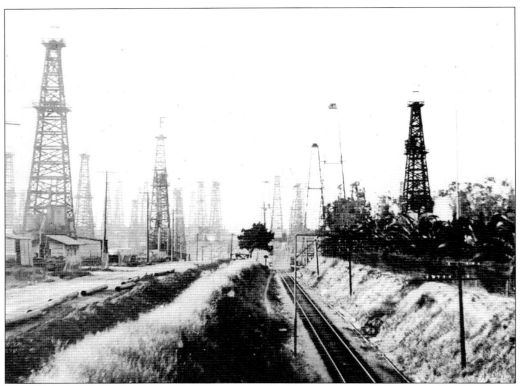

This is a great look down the tract used by the electric car that brought people from Los Angeles to the beach. The popular ride cut through the rising derricks of Signal Hill on its route.

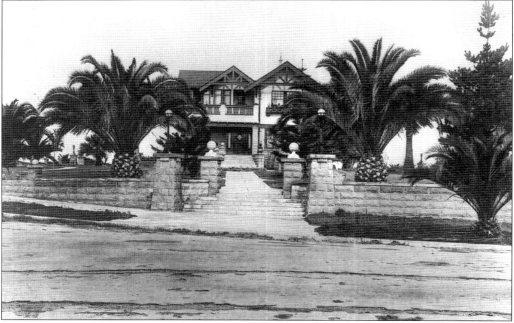

Above is a peaceful scene of the Denni home on the hilltop before being overcome with derricks.

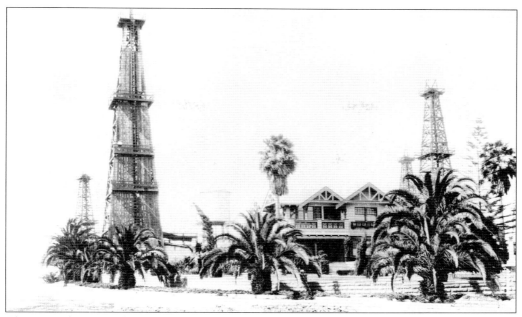

The Denni home was built in 1915 and had some good years before being pushed out by oil. This is where the new Hilltop Promontory homes currently rest. The oil companies have found clever ways to still pump oil between the homes without being seen. They are better neighbors today than they were back then.

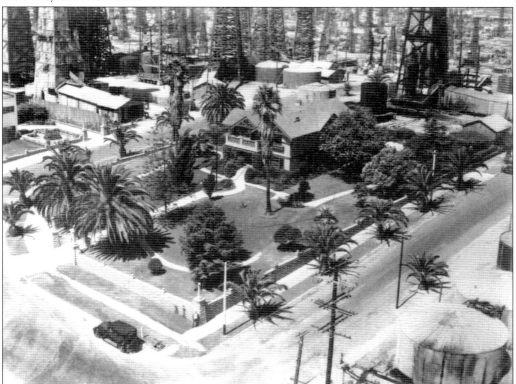

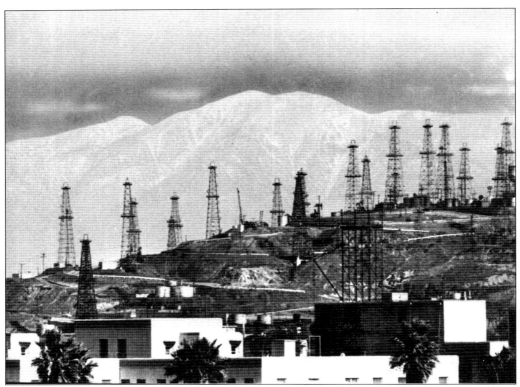

On a clear day, Mount Baldy can be seen. City hall is in the foreground, and the derricks of Signal Hill are silhouettes against the San Gabriel Mountains.

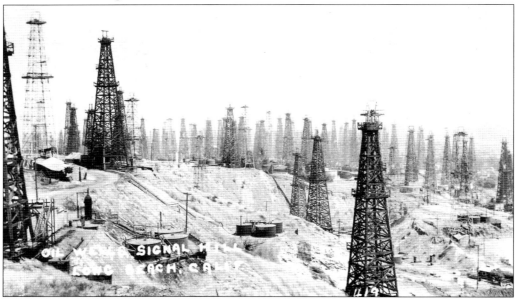

The south slope of the Hill has lost its derricks and added million-dollar townhomes. The developer has left some open space along this area that is enjoyed by many area residents as a steep off-road walking experience with terrific views.

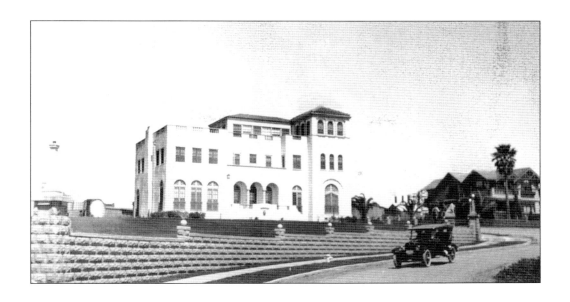

In 1921, Andres Pala estimated that his pink mansion near the crest of the Hill was worth $15,000. The oil strike hit the next day, and he was turning down offers of $150,000. Neighbor Lewis Denni held out for a few months and sold his land for an unheard of 50-percent oil royalty. The Denni home was torn down right away to get the drilling started before the oil ran out. The oil company later purchased the Pala Mansion, and it served as an office for several years.

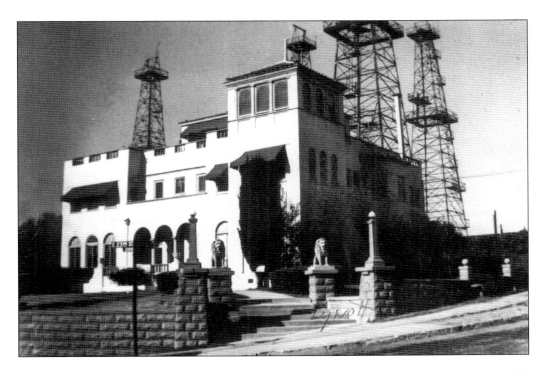

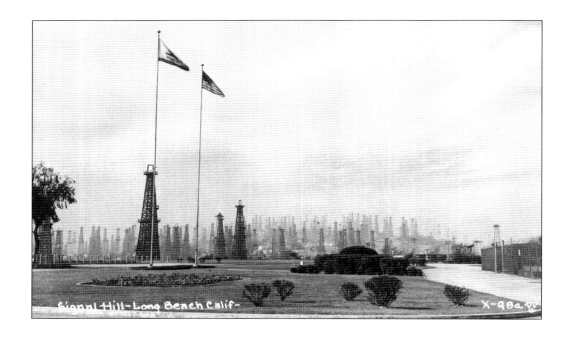

This manicured open space (above) is contrasted by the background scene of oil derricks fighting for a spot on the Hill. Famous photographer Ansel Adams took a photograph of a monument statue in Sunnyside Cemetery with the mass of derricks in the background (not pictured), capturing a juxtaposition of serenity and industry similar to the image below.

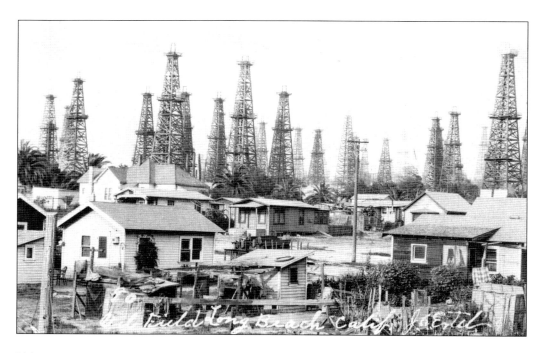

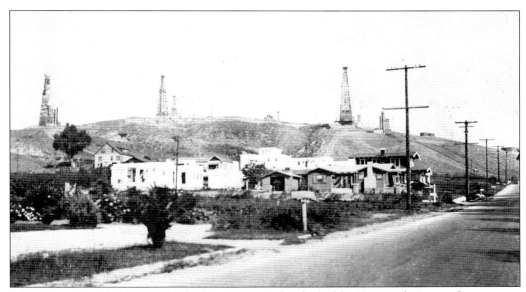

This is a great early photograph looking east on what looks like Twentieth Street, showing just a few derricks rising in the distance. The tree on the left is on Cherry Avenue. (Photograph courtesy of Mark Fowle.)

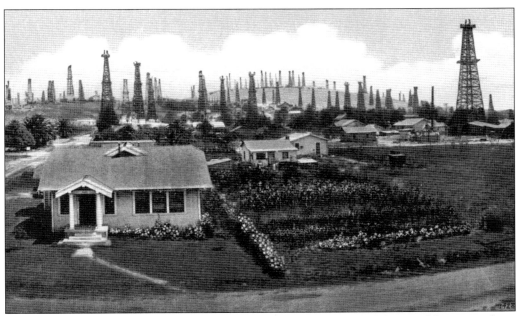

This small home with flowers and a vegetable garden seems to stand in defiance of the approaching oil derricks.

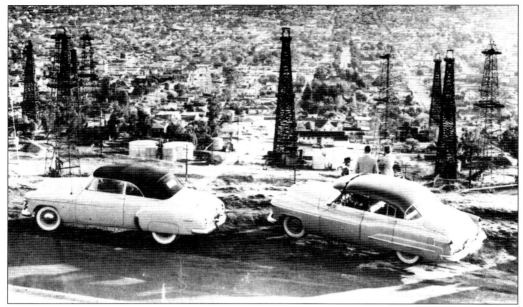

These cars pulled out onto the side of the road to take in the view. This photograph looks south toward the ocean.

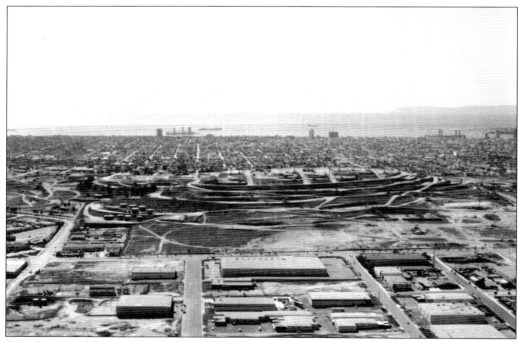

Cut clean for development in this 1970s photograph, a person can appreciate how much has changed over the past 30 years. Costco, Home Depot, Office Depot, and automobile dealers all took their spot in the foreground and brought needed sales tax revenue.

The Signal Hill water tower stood tall at the top of the Hill for many years. This local landmark was lost in the development of homes on the hilltop.

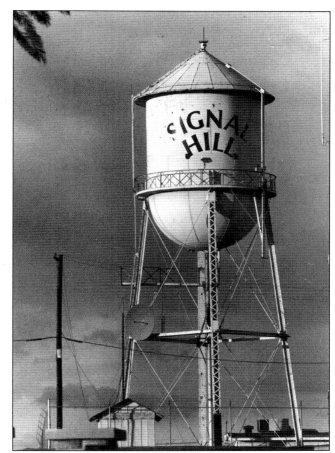

One of the early condominium buildings is under construction along Skyline and Panorama Drives. It still shares the space with oil derricks today.

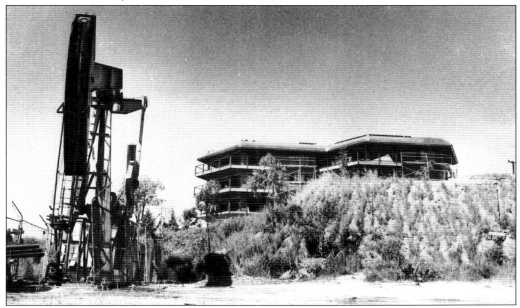

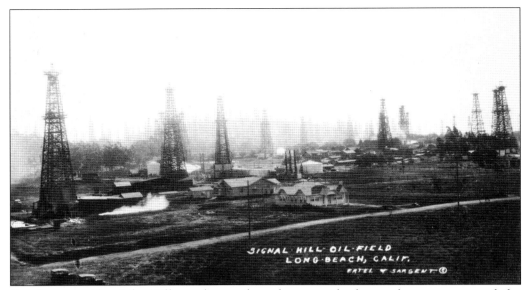

On the west side of the Hill stood many large homes with plenty of open space until the derricks came.

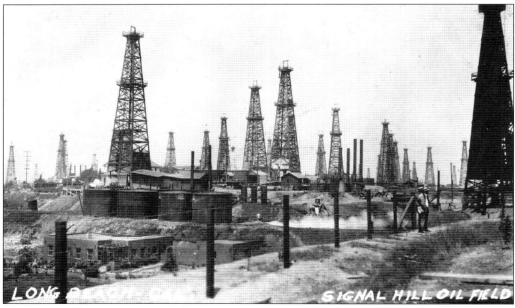

This is a northwest view from Cherry Avenue at the pullout looking towards Burnett Street. Today this area is under development as Crescent Heights.

Pictured here are homes surrounded by a forest of derricks. These people just carried on their lives with all the noise, smell, and muck from oil production.

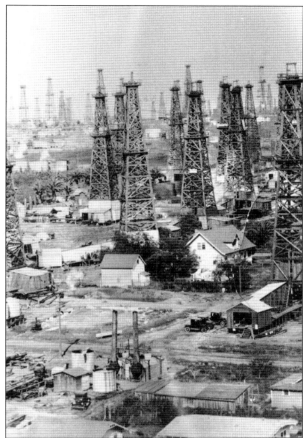

Seen from Spud Baseball Field are city hall, the firehouse, and the old community center standing in the large open space that is now Signal Hill Park.

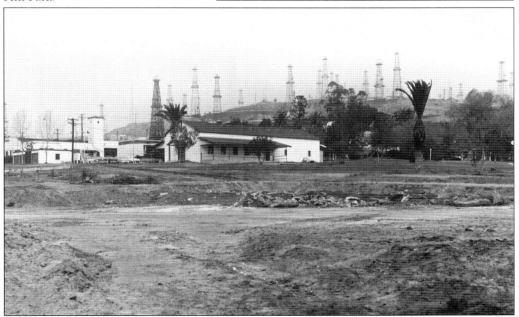

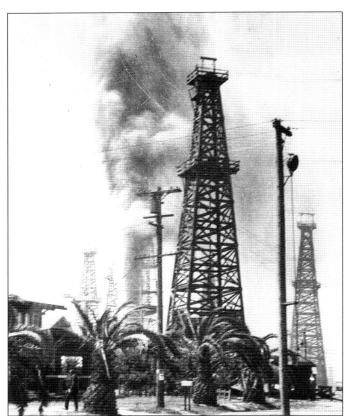

This is the gusher that spelled the end to most of the homes in Crescent Heights. It is most likely Rose Avenue, where the home to the left is still standing.

The dark two-story home (back center) is on Burnett Street in Crescent Heights and is still there. The homes above it (back right) were lost. The unusual homes on Creston Avenue (front center) are long gone, but the site of some new development ideas.

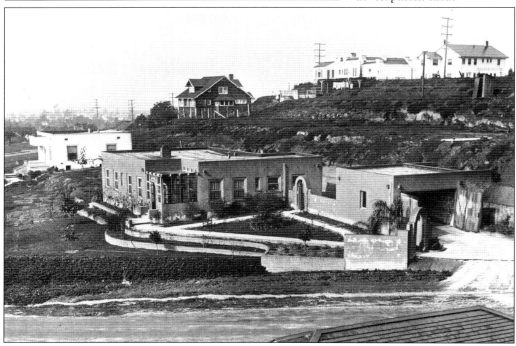

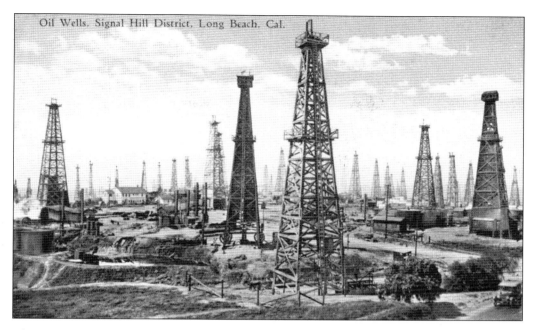

The Crescent Heights postcard above exemplifies a residential area overcome with industry. Below, the top half of a two-story home is being relocated into the new historic district. This home sat on the ocean edge in Long Beach and was moved to make way for a high-rise condominium project.

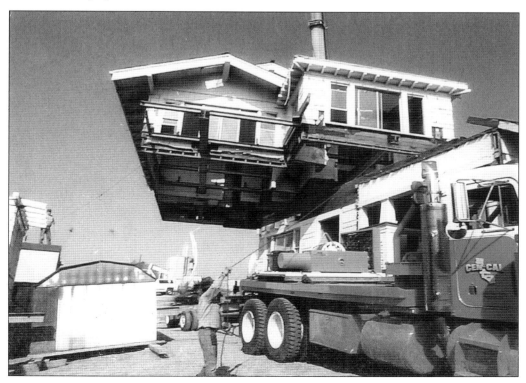

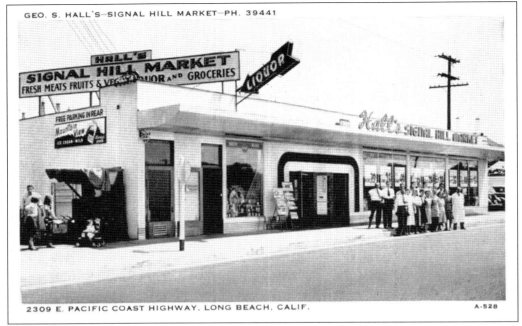

This is George Hall's Signal Hill Market at 2309 East Pacific Coast Highway. This postcard is from Neena Strichart's collection (current owner of the *Signal* newspaper), and she has many fond memories of shopping and hanging out at this local favorite hot spot.

This tire shop sat at the corner of Hill Street and Orange Avenue.

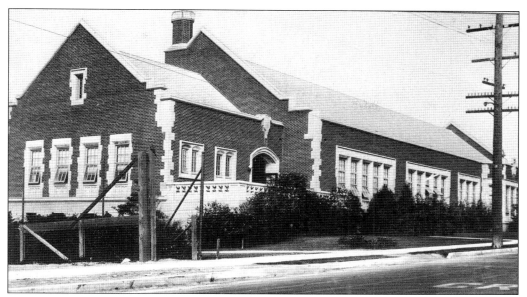
Signal Hill Grammar School is pictured in 1926 before it was torn down.

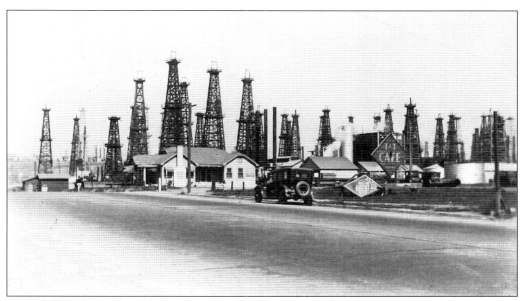
The T&T Café sits along the road ready to feed hungry roughnecks.

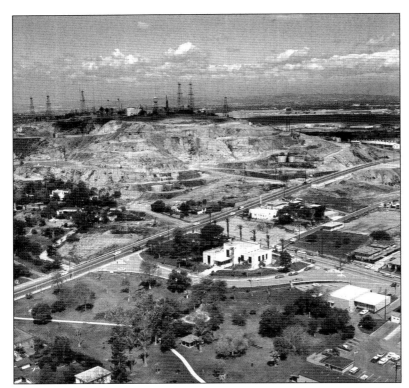

These are spectacular aerial images of Signal Hill, prior to the new development. Note here and on page 125 that the photographer in the helicopter rotated to capture all the areas surrounding city hall.

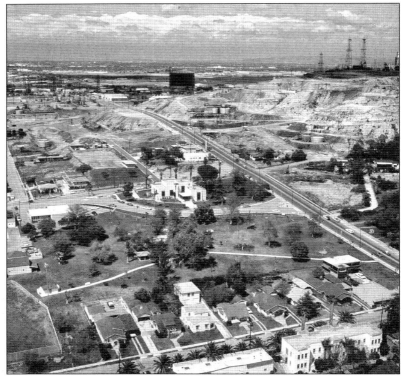

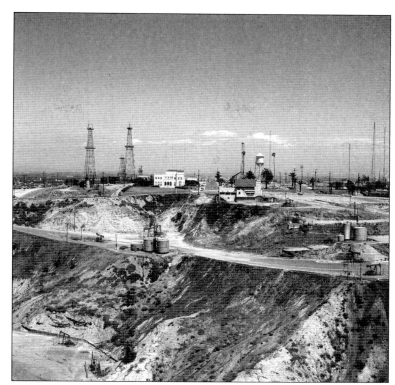

These close-up images from above of the hilltop show the Pala Mansion, the water tower, and the Hilltop Star Room.

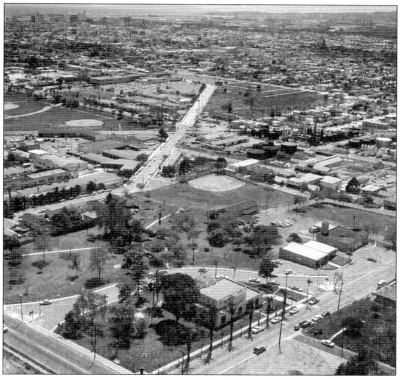

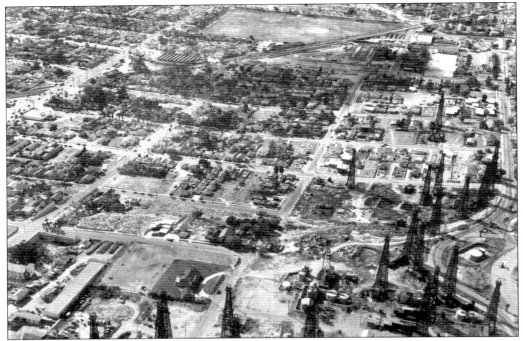

This is an aerial view of the southeast neighborhood, with Twentieth Street in the center (the vertical street), separated by Stanley Avenue at the upper side and Molino Avenue below. Note the large estate on Twentieth Street between Molino and Temple Avenues that is now occupied by large condominiums.

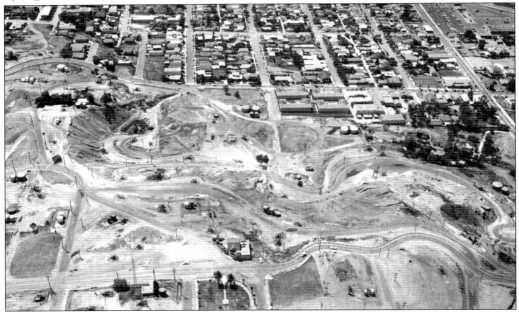

Hilltop Panorama Drive can be seen from the air with the walkway to the Denni home still across from the Star Room. The full south slope above Twenty-first Street is visible, left barren by the oil operations. The oil company reconditioned this land and developed most of the area.

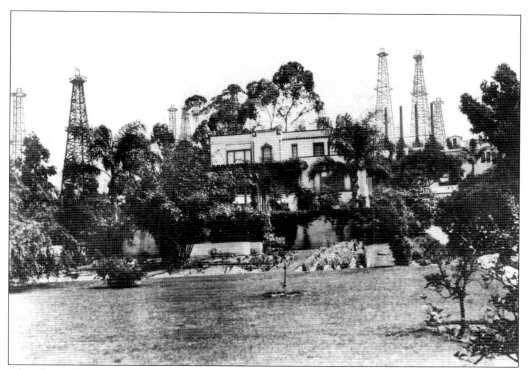

This fine old home was converted into a retirement community before it was developed into condiminiums.

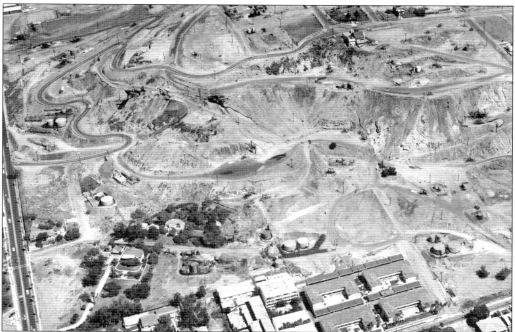

In 1972, the retirement community can still be seen, as well as another large home just east of Cherry Avenue. The apartments on the lower edge are on Twenty-first Street.

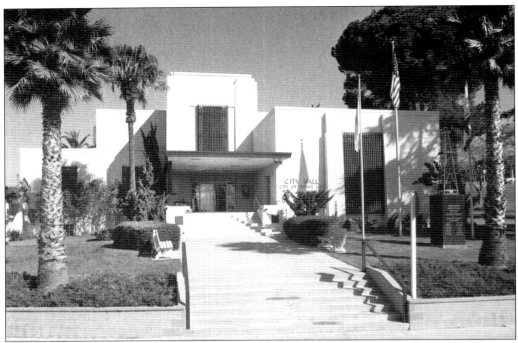

It is fitting that the last images of this book should be of city hall (above) and the Signal Hill Library (below) that was originally located on city hall's top floor. City council and many in the community are working hard to build a modern library, as it has been housed in what is the old firehouse for some time. It is the hope in the community that people will be able to find this book in that new library and see how much has changed in the city of Signal Hill.

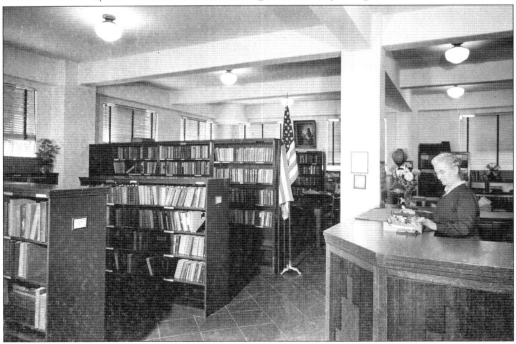